S0-BSD-651

ANGRY GRAPHICS

Protest Posters
of the Reagan/Bush Era

ANG
GRAPH

Protest Posters
of the Reagan/Bush Era

PEREGRINE SMITH BOOKS
SALT LAKE CITY

RY
ICS

Karrie Jacobs
& Steven Heller

MARY SISKIN AND ANNE FINK, RESEARCHERS

© 1992 BY STEVEN HELLER AND KARRIE JACOBS
FIRST EDITION
96 95 94 93 92 5 4 3 2 1

ALL RIGHTS RESERVED. NO PORTION OF THIS BOOK MAY BE REPRODUCED IN ANY
MANNER WHATSOEVER WITHOUT WRITTEN PERMISSION FROM THE PUBLISHER.
THIS IS A PEREGRINE SMITH BOOK
PUBLISHED BY GIBBS SMITH, PUBLISHER
P.O. BOX 667 LAYTON, UTAH 84041 (801) 544-9800

DESIGN BY LARRY CLARKSON, CLARKSON CREATIVE, SALT LAKE CITY
COVER PHOTOGRAPH BY KRISTINE LARSEN, COVER POSTER IMAGE BY JOSH GOSFIELD
PRINTED AND BOUND IN SINGAPORE

LIBRARY OF CONGRESS CATALOGING-IN-PUBLICATION DATA
HELLER, STEVEN
 ANGRY GRAPHICS / STEVEN HELLER & KARRIE JACOBS.
 P. CM.
 INCLUDES INDEX.
 ISBN 0-87905-469-7 (PB) :
I. POLITICAL POSTERS, AMERICAN. 2. UNITED STATES—POLITICS AND GOVERNMENT—
1981-1989—POSTERS. 3. UNITED STATES—POLITICS AND GOVERNMENT—1989-—POSTERS.
4. ART, AMERICAN—POLITICAL ASPECTS. 5. ART, MODERN—20TH CENTURY—UNITED STATES.
I. JACOBS, KARRIE, 1957-. II. TITLE.
E169.12.H45 1992
973.927'0222—DC20 92-5926
 CIP

Acknowledgments

Very special thanks to those whose guidance and knowledge were invaluable in preparing this collection: Barbara Moore at the PAD/D Archive, Clive Philpot and the staff at the Museum of Modern Art library in New York, Scott Cunningham, Anton Van Dalen, Andrew Castrucci, Peter Kuper, Seth Tobocman, Scott Braley for Fireworks Graphics Collective, Art Chantry, Mike Rossman, Robbie Conal, Esther Hernandez, Sue Coe, Barbara Kruger, Lincoln Cushing for Inkworks, and Tim Drescher.

Thanks to the individuals and groups who allowed us access to their collections: Printed Matter, Inc.; the War Resisters League; Guerrilla Girls; Gay Men's Health Crisis in New York; Gran Fury; Gang; Art Fux Collective; ACT-UP; The Schomburg Center in New York; Bobbie Josepher at the Sierra Club; Jan Arneson at the United Nations; Ricardo Levins Morales at Northland Press in Minneapolis; La Raza Graphics in San Francisco; Carol Wells at the Center for Study of Political Graphics; James Fraser at Fairleigh Dickinson University in Madison, New Jersey; and the street poster artists of Loisaida and Soho.

Thanks to Steve Chapman at Peregrine Smith for inviting us to do this book, and to Heather Bennett, our editor, and Madge Baird, editorial director at Peregrine Smith. We are grateful to Larry Clarkson, the designer, and to Edward Spiro for his photographic skills.

Most important, this project could never have been accomplished without the tireless efforts of our researchers, Mary Siskin and Anne Fink, who uncovered more material than we ever expected.

Finally thanks to all the artists, collectives, groups, and organizations whose work was submitted for our consideration; their efforts keep us aware that injustice is a national disease.

Angry Graphics is ninety-six pages long. We could easily have made it ten times longer. We could have compiled an encyclopedia of protest graphics based on the material sent to us by designers, artists, collectives, and organizations all over the United States.

What this indicates to us is that conventional wisdom is wrong. The last decade has supposedly been a time of indifference to social problems and political concerns. But small groups and individuals have continued, passionately and skillfully, to express themselves on a multitude of issues. The process of selecting posters for this book was tough and surprising. Who knew that in 1980 black light posters were printed protesting Iraq's treatment of the Kurds? Who knew that there were artists like the Bay Area's Rupert Garcia who were quick enough to silk-screen posters protesting the 1989 invasion of Panama?

We're encouraged by the vitality of the work we're presenting, as well as the work we were forced to leave out. We wish we could document all of it. While the posters in this book are often the work of lone artists and designers, there are numerous organizations like San Francisco's Fireworks Graphics Collective, and print shops like New York's Black Cat Press, which specialize in printing and distributing these broadsheets. In many cities there are volunteer snipers who go out into the night with a sheaf of posters and a bucket of wheat paste. These are not vandals. This is not the lunatic fringe. This is evidence that participatory democracy is alive and, if not well, recuperating.

Karrie Jacobs and Steven Heller
New York, December 7, 1991

1

HIT & RUN

a legacy of UNofficial graphic protest

Steven Heller

In 1942 a small group of German university students from Munich calling themselves the White Rose began a modest propaganda campaign against the Nazis. For over a year the Gestapo was frustrated by the group's ability to escape capture while disseminating antigovernment manifestos and eyewitness accounts of Eastern Front atrocities. Armed with mimeographed leaflets distributed in small quantities (owing to limited paper supplies), they set out to incite rebellion and mutiny among students and soldiers. This was not an easy mission since university students had been fed Nazi doctrine since childhood; they were conditioned by Nazi slogans and worshiped Nazi icons. Even if they weren't Nazis, they were unwilling to rebel. The members of the White Rose became tireless propagandists, but one day their luck ran out, and most members were arrested, tried, and summarily hanged as enemies of the state.

Much like other activists, the White Rose communicated truth with limited means. They couldn't compete with the sophisticated visual and verbal propaganda that the Nazis brilliantly manipulated even before they came to power in 1933. Instead they took the simplest, most straight forward approach—the printed word. Their austere, typewritten manifestos were not embellished by design. In a nation where graphic design was highly valued as a propaganda tool—indeed no other twentieth-century national identity has been as systematically developed—the White Rose's materials were so graphically understated that they cannot even be described as designed.

This was not a conscious decision by the members of the White Rose. Many were artists, but without access to printing presses or color separations, their efforts had to be simple. Like resistance groups throughout history, they used the available tools—in this case the 1940s' desktop publishing equivalent: a typewriter and mimeograph machine. Yet printed protest has not always been as austere as this. Quality and quantity have always been dictated by whether or not the ruling power has allowed its opposition to exist.

Hit-and-run graphic attacks on officialdom have a long history. The earliest example can be traced to Egypt, where anthropomorphized caricatures lampooned slave masters. In Greece and Rome critical satiric drawings and sculptures occasionally surfaced, though the makers were threatened with harsh punishment. Likewise, before the invention of the printing press in the mid-fifteenth century, examples of indignant protest art were either rare or destroyed. During the Renaissance engraved prints by Dutch, German, and Italian social critics appeared in increasing numbers but were still limited. By the

eighteenth century, however, critical art was an accepted genre in England, where freedoms were more or less permitted, but in nations where rulers maintained a stranglehold on expression, visual and written protest had to be distributed through underground channels. Unofficial printed protest became a staple of political struggle in nineteenth-century Europe, when social revolution and an advanced printing technology increased the need and ability to produce strident commentary.

Technical difficulties involved in printing pictures together with text dictated that early nineteenth-century graphic protest, like most official printed matter, be set in type, often using poor-quality metal or wood fonts. While cartoonists were active, their work was usually printed in small quantities as engravings or etchings. With the advent in the early nineteenth century of stone lithography as a commercial printing process, the artist and typographer were finally joined. This union was no more explosive than in 1831, when citizen King Louis Philippe ascended to the throne of France. Newspapers and broadsides criticized in words and pictures the new government's rejection of republican values. When Louis Philippe banned satiric imagery of himself and his ministers as threats to public security, protest artists—most notably Honoré Daumier—found alternative outlets in periodicals, leaflets and posters, in which innocent social commentary was transformed into strident political critique.

Satiric periodicals were common in most European capitals during the late-nineteenth and early-twentieth centuries, and were tolerated by the authorities to allow for the human need to vent steam. In France there were scores of political journals during the intermittent periods of press freedom following the fall of Louis Philippe and the defeat later of another autocrat, Louis Napoleon. And although Germany was ruled in the 1890s by the imperious kaiser, critical words and pictures were widely distributed there in periodicals such as *Simplicissimus* and *Jugend*, which produced a genre of the most acerbic political cartooning in Europe at that time. The Munich-based *Simplicissimus*, banned twice by monarchal decree for blasphemy, was almost exclusively visual; powerfully rendered, captioned cartoons stood by themselves as independent statements or served as part of an issue devoted to a specific theme.

The French version of *Simplicissimus*, called *L'Assiette au Beurre* (1901-12), was supplied with acerbic cartoons by an international repertory of graphic commentators whose opposition to the growing French bureaucracy, oligarchy, and privileged class, and support of the working class and peasantry, was reflected in strong posterlike images. The Austrians, Italians, Dutch, and Norwegians also followed *Simplicissimus's* lead, but it was the Russians who applied the model best when in 1905-06, they rebelled against the czar in their first short-lived insurrection. Scores of critical (or officially "seditious") journals were published during that period, most lasting only a few issues before being shut down by authorities.

These emotionally charged publications, with descriptive titles like *The Sting* and *Wasp*, were printed in clandestine print shops in Moscow and St. Petersburg (their editors were always one step ahead of the censor), yet their graphic and conceptual quality was surprisingly high. Though the revolution was suppressed in 1906, the artistic evidence of czarist persecution remains a monument to effective resistance. Eleven years later the artists and designers who had spent the intervening period developing the radical language of constructivism dedicated themselves to a revolution which transformed the vocabulary of opposition into an official language. The leaders of the 1917 revolution understood that posters and other visual media, such as

film, would be the key in swaying a largely illiterate populace.

Typically these graphics in the service of revolution were narrative multiple images or powerful single icons, which, owing to the scarcity of paper, ink and type, were often printed from stencils in limited quantities and displayed in the windows of telegraph and post offices. A hybrid of the comic strip and the cartoon, these telephone and telegraph office (ROSTA) window graphics were an effective means of simplifying complex ideas. However, despite the best efforts of the artists and designers to introduce art into everyday life, the reactionary Soviet leadership, by the late 1920s, had denounced the revolutionary

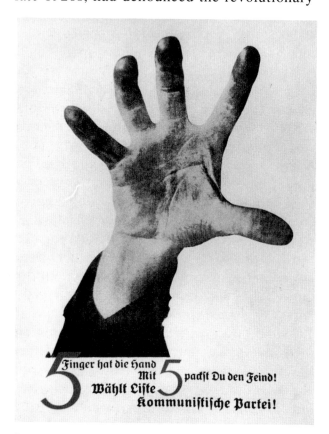

A hand has five fingers. With five you can repel the enemy! Vote List Five.
John Heartfield, 1928
Communist Party Campaign Poster

visual language for being above the heads of the masses. They replaced it with an unambiguous socialist realism.

Following its defeat in World War I, the German monarchy was replaced by a fragile republic. The 1920s brought a devastating economic depression that polarized factions vying for greater political power. Characterizing this era in German history were frequent street battles between the government and its opponents on both sides of the political spectrum. The graphics–posters, stenciled slogans, and party symbols–were equally incendiary. Working unofficially, but above ground, the Communist and Nazi parties competed to create the most effective propaganda. The communists, many of whom were associated with German Dada, had the most striking graphics–the most memorable being John Heartfield's "five finger" election poster for the Communist party, a masterpiece of symbolic simplicity: the five fingers on a laborer's dirty, outstretched hand are poised as if to grab the passerby. Five was not only the date of the election but the "list" or row number where the Communist candidates were to be found on the ballot.

The lesson here is that the best graphics don't always win. German Communism and its leadership (not a few of whom were killed by their enemies) were no match for the charismatic Hitler and his propaganda efforts.

Between the wars America also experienced economic and political turmoil with deep factional (as well as racial and religious) polarization. Right and Left groups in America also vied for power by tapping into the mainstream media, including radio and print. The Left always had the better graphic materials. In fact many of the American artists who were committed to social reform produced protest art in the twenties and were eventually employed by F.D.R.'s New Deal in the thirties.

In addition to the famous WPA graphics, unofficial propaganda campaigns to abolish war, raise literacy, and grant equal rights were mounted in many parts of the country, featuring graphic works that ranged from crude to professional. Posters were the cheapest and most effective means of disseminating ideas. When the war against the Axis began, most of these artists used their skills to support the war effort.

In America in the early 1950s, two issues became inextricably wed: the Red scare and the bomb. Though a majority of Americans were indifferent, many lives and livelihoods were threatened by denunciation for being Communist. At the same time fear of the bomb was growing. A small band of intrepid graphic guerrillas mounted visual attacks against McCarthyism and nuclear war. In the fifties artists joined groups like SANE (National Association for a SANE Policy) in order to increase popular opposition to nuclear weapons and produce cautionary reminders that the worst fate was a real possibility.

The fifties were not as dull as mythmakers assert: even President Eisenhower warned about the buildup of a "military industrial complex" (a term he coined). Moreover the times were politically and socially charged. The prototype of a sixties underground (or alternative) newspaper was born in the fifties with *The Independent*; Jules Feiffer published his first satiric cartoons in *The Village Voice*; civil-rights marches and activist support groups were forming. A renaissance in graphic protest art flowered in the 1960s.

The mid-to-late 1960s was the paradigm for contemporary social activism; it was not only a period when major issues of war, peace, gender and race were coming to the fore, but every conceivable tool of propaganda was marshaled into service–print, buttons, banners, film, radio, records, performance art, and demonstration. In the United States all media (even mass media) were available to the opposition. Two primary factors contributed to the plethora of printed material that emerged in such a relatively short period of time: inexpensive offset lithography and Xerox technology. Offset lithography provided groups and individuals having limited resources with the ability to produce newspapers, magazines, broadsheets, even cheap posters on inexpensive paper with numerous colors. As primitive as it was then, photocopying brought the cost down even further and increased the ability of grass-roots groups who did not have design knowledge or skills to reach the public with small handbills and leaflets. Eventually "quick copy" stores offering offset and Xerox allowed for even greater opportunities.

The sixties was also a time of cultural scavenging. The graphic language of sixties protest was an amalgam of new and old–borrowed and stolen images from history–mainly because it was *free*. Psychedelia, the dominant graphic form, was a flea-market style of venerable advertising images. East Indian motifs and old-fashioned wood types were reprised and updated by the addition of drug-stimulated vibrating colors. Many of the most memorable images came from past epochs of protest, given new life by contemporary contexts. For example, while the most controversial cover of *Ramparts* magazine (art-directed by Dugald Stermer) showed four burning draft cards, a decidedly contemporary phenomenon, the most *unforgettable* of their covers pictured an American flag with black and red stripes and skulls in place of stars, a strident comment on the carnage of the Vietnam War. The image was actually designed by Mark Twain in 1901 as a protest against American policies (and was recently revived to draw attention to George Bush's deficient AIDS policy).

Another "new Left" journal, *The East Village Other*, often reprinted or borrowed elements from the anti-Nazi photomontages John Heartfield had

5

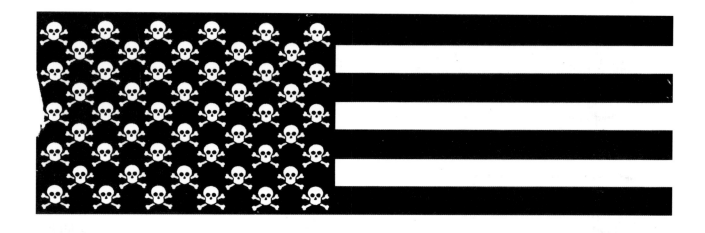

BUSH AIDS FLAG

Bush AIDS Flag
Frank Smithson (designer), Robert Birch (art director), 1991
ACT-UP, New York City

made in the 1930s, recognizing their curiously timeless applicability. For reasons of speed and cost, photomontage was also the strategy of many underground-press scavenger artists. Despite many reprises the most memorable iconography, especially posters created by the underground press and opposition groups, was original and contemporary. Lorraine Schneider's "War Is Not Healthy for Children and Other Living Things," Seymour Chwast's "End Bad Breath," and the chilling (anonymous) My Lai massacre poster, showing the bodies of civilians on a dirt road, remain among the most powerful images of the era.

Despite government dirty tricks and infiltrations, the sixties marked a renaissance of protest. Unlike the German White Rose, the American underground, civil rights, and antiwar movements had relatively free access to media. With opposition to the war on the evening news and front pages across the country, protest artists escalated their attacks in an all-out effort to change policy. Small groups had a great impact on a variety of issues. For example immediately after the prisoner uprising and subsequent brutal

6

reprisal at New York State's Attica prison, artists of *The New York Ace* quickly designed, printed, and sniped (illegally hung) posters calling for a complete investigation. Similarly, in response to a variety of social crises, *Ramparts* issued wall-poster newspapers in San Francisco to present alternatives to official statements.

Eventually in the late sixties, the graphic guerrillas were joined, if not eclipsed, by the mainstream. Certain advertising bad boys loaned their marketing skills to the "movement" with posters like "I Want You," showing a plaintive and tormented Uncle Sam in a send-up of the classic James Montgomery Flagg recruiting poster. Indeed a poster craze hit the nation, whereby celebrity and protest posters shared display space in head shops around the country. On occasion celebrity and protest actually merged: Remember the poster showing a pregnant black woman with the headline, "Nixon's the One!"? And who can forget the photograph of Black Panther leader Bobby Seale majestically sitting on a wicker throne with gun and spear? Both sold briskly on campuses.

The pullout of American troops from Vietnam in 1973 effectively ended mass media's attention on popular protest, but the protest itself did not end. Throughout the 1970s social discontent continued, fear of nuclear destruction increased, racial strife escalated, and the environment took center stage. While protest art in the United States became less visible, it was not dead as some would contend. Direct mail campaigns replaced guerrilla poster activity. In fact the poster, folded and quartered, became a mailing, rather than a hanging, piece.

Ronald Reagan sanctioned a return to social isolationism. Official indifference to social need trickled down into communities everywhere. The result of a decade of conservative ideology and liberal inactivity was an increasing underclass. Responding to local health, housing, and economic crises, a number of grass-roots graphic groups emerged in urban and rural areas throughout the nation. Professional and student artists and designers not only protested against national indifference using traditional methods, but found the means to help their communities by exploiting various new communications technologies–personal computers, portable copiers, fax, and more. Provoked by Reagan's indifference toward the poor and disregard of women's rights, and pushed by the AIDS crisis, activism increased in the eighties. Graphic guerrillas shot off countless paper bullets and mounted many street actions in battles against an enormous variety of social crimes. The evidence is indelible in any city where posters and broadsides are hung; the quantity is large and the quality is high. Today marks a new renaissance of visual protest, perhaps the most impressive yet, as this nation's grass-roots organizations, graphic collectives and brigades, with concerned individuals continue to create printed manifestos that fight indifference.

NIGHT DISCOURSE

Karrie Jacobs

n New York City, at the point where the logically numbered grid that covers two-thirds of Manhattan abruptly ends, where Zero Street ought to be, there is a broad, raucous, smelly boulevard called Houston Street. And at the corner of Broadway and Houston, an intersection that can be thought of as the gateway to Soho, New York's art district, there is a pair of billboards mounted on the side of a building. These billboards have unofficially been, for a number of years, the art billboards. One of them is usually an ad for Keith Haring's Pop Shop, while the other one is frequently a project or political statement by an individual artist.

Early in 1991, during the Gulf War, there appeared here a billboard that said, in crude orange letters: "The New World Order." Beneath the type was a reproduction of *Guernica*, Picasso's outcry against Fascist bombing during the Spanish Civil War. The other billboard carried an antiwar message by a prolific conceptualist from Jersey City, New Jersey who goes by the name of "Artfux." Several days after these protests appeared, I looked up and both billboards had been covered over with identical maps of the Persian Gulf, decorated with stars and stripes, bearing the message: "Support our troops in the Middle East."

I couldn't figure out how this switch had happened. The prowar sentiment seemed so un-New York, so un-Manhattan. I started making phone calls. Eventually I reached the billboards' leasing agent to ask what was going on and discovered that neither set of billboard images had actually been put up legally. This was not surprising. This was very New York.

The lessor said, "I don't know anything about it. Sounds like who's doing it is President Bush and the other guy. What's that guy's name? The one who's causing all this trouble?"

"Saddam Hussein?" I ventured.

"Yeah. Sounds like they're doing it."

Whoever did it, however it happened, this exchange of opinions occurred during the night: surreptitiously, illegally, mysteriously. This political debate about the Gulf War transpired while the rest of us were sleeping. I think of this phenomenon as "night discourse."

Night discourse is a much more blunt, more argumentative form of communication than its daytime counterparts, the editorial pages of newspapers and the Sunday-morning public-affairs television shows. Think of it as 3:00 A.M. talk radio made visible. The most biting political statements are pasted up all over the city at night: on walls, over existing billboards, and especially on plywood construction fences. Then in the daytime we see them as we walk the streets: on our way to work, to get some scrambled eggs, to have

8

our teeth cleaned. Sometimes we pay attention and sometimes we don't.

This form of public display is called "sniping" by its practitioners. Sniping is the repeated and methodical postering of a given location. The posters placed by the most skilled and persistent snipers will survive the longest. The rest will be swiftly torn down or pasted over.

The poster walls which result from sniping offer a highly visible, continuous graphics exhibition, one that's neither judged nor curated. It's a show that's hung and rehung nightly, mostly by professional posterers, the pirates of the outdoor advertising world. These walls, called hoardings, have been used in this matter, more or less illegally, for at least a century.

Magazines and newspapers have standards that govern the appearance and content of the advertising they accept. Companies which lease outdoor and transit advertising space have rules about what is and isn't appropriate. But the city's walls and fences operate beyond the forces of law and propriety. As a result, some of the strongest and most innovative graphics can be found only in this setting.

Postering as a means of advertising for pop bands and concerts, art events, movies and even television shows appears, in my unscientific estimation (based on what I see when I walk down the street), to be on the rise. It is used even by those who also employ more conventional means of advertising–who generally pay for space on billboards and airtime on television– as a way of generating word of mouth, of getting the man on the street–literally–to talk about their product or event. So the fences and walls are crowded with posters advertising a new Sean Connery movie called *Highlander 2: The Quickening*, or a festival of movies by the director

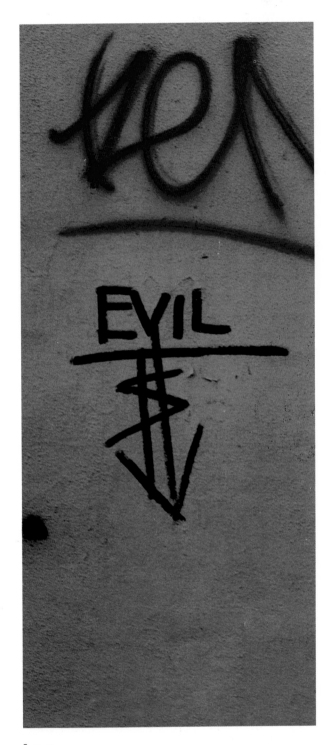

Evil
Artisit Unknown, 1991
Graffiti on the Lower East Side, Manhattan

Henry Jaglom, or a poster for an exhibition by photographer Matthew Rolston. The hoardings have cachet. Things advertised on them seem hip, whether or not they really are. Because they are advertised through a pirate medium, these events possess an air of obscurity, as if they're emanating from the underground.

If we think of the fences as a kind of outdoor magazine, the commercial posters are the advertising and the political posters comprise the editorial content. The political posters are missives from people with a message, snipers with a chip on their shoulders. For instance there is currently an anonymous sniper, angry about the state of the art market, who has been pasting detailed editorial cartoons on the fences of Soho. "Art is buisiness [sic] and buisiness [sic] is art," says the headline of one such cartoon. On the left is a drawing of a poor, worn-out-looking man sitting on an apple crate, his shabby walls hung with paintings by the great masters. The caption says, "I sold art." On the right is a fat man sucking on a cigar; a computer on his desk is spewing a printout of his clients: the Museum of Modern Art, the Guggenheim Museum, the National Endowment for the Arts. On his walls are collages made from broken record albums and objects like a Quaker Oats container. The caption says, "I sold 'fadism' as art."

Further down the fence is a more professionally made poster. Its headline says, "Unnatural Histories: Pea Brains." Below there is a blowup of a *Newsweek* cover: "The New Politics of Race." Running on top of the cover reproduction, there's the text of an article that pretends to be from that issue of *Newsweek*. It's about White House officials trying to formulate an appropriate response to a nineteenth-century study in which the cranial capacity of different races was measured by filling skull cavities with peas. The supposed study demonstrated that the skulls of black men could hold fewer peas.

The article says: "A senior White House official added, 'At first we thought we were in a no win situation. If we denounce the study, we'll be accused of trashing Western culture and tradition, and if we support its findings, we'll be accused of being insensitive to blacks.'"

For a paragraph or two, the article seems stupid but plausible. Then as it progresses, its satirical message becomes more evident. White House officials also deny that "a pubic hair for every Coke" is George Bush's new campaign slogan.

It becomes clear that this poster is a commentary on the inability of Congress or the media to effectively cope with the Clarence Thomas Supreme Court nomination. What isn't clear is the exact political viewpoint of the person who made the poster.

Political posters these days are rarely as predictable as they once were. Today it's difficult to distill one's political views down to an effective poster. Nothing is simple and clear.

The posters of the sixties and seventies relied on a set of symbols–the peace sign, the dove, the clenched fist, the sign for female paired with the clenched fist, the altered flag–which made their messages blatant. There was little ambiguity in those graphics, just as there was little ambiguity in the politics of that period. The battle lines were clearly drawn.

Today's movement politics are very different. There is no one issue such as the Vietnam War to neatly identify the sides. Posters still address the standard themes: peace, the environment, and social justice. But there are new themes as well. AIDS and the questions it raises about health care, sexuality, and the government's priorities in funding research have inspired a whole new category of angry graphics. And today's political posters seem less likely to be the recognizable output of a

coherent movement and more likely to be an individual expression of outrage, the work of one angry person, or one angry person along with a few angry friends. It is as if the Reagan era's idealization of private enterprise has even affected the way people protest.

The one symbol that has emerged in the last decade, as powerful and recognizable as the icons of earlier decades, is the pink triangle paired with the equation SILENCE = DEATH. First pasted onto New York City's walls by a group of six gay men who called themselves the SILENCE = DEATH Project, the symbol was, in 1987, adopted and popularized by the AIDS Coalition to Unleash Power, ACT-UP. It's directly inspired by the upside-down pink triangle that the Nazis required homosexuals to wear, but in the way it assigns meaning to an abstract form, it's reminiscent of El Lissitsky's great constructivist political poster, "Beat the Whites with the Red Wedge." In that 1920 poster the artist used a red triangle to stand for the Bolsheviks and their cause.

In the book *AIDS Demo Graphics*, the authors, art critic Douglas Crimp and architect/artist Adam Rolston, document the graphics used by ACT-UP and related organizations through a chronological account of AIDS protests. Of the SILENCE = DEATH logo, the authors write: "It is not merely what SILENCE = DEATH says, but also how it looks that gives it its particular force. The power of the equation under a triangle is the compression of its connotation into a logo, a logo so striking that you ultimately have to ask–if you don't already know–'What does that mean?'"

Sexism Rears Its Unprotected Head
Gran Fury, 1989
Poster/Billboard For ACT-UP, New York

Rolston, in an interview, has commented: "SILENCE = DEATH, it looked like a corporate logo, like some institution was speaking to me. It's the appropriation of the voice of authority. Like a trick."

Of all the political posterers, of all the participants in night discourse, the anti-AIDS activists are the most forceful and unambiguous. While others tend to obscure their meaning with awkward delivery, ACT-UP and its spin-off collectives, Gran Fury (named for the Plymouth car model favored by undercover police in New York) and Gang, exploit the knowledge they've accumulated from daily exposure to advertising. They are in the business of generating anger as efficiently as possible. Notes Gran Fury member Loring McAlpin, "We are trying to fight for attention as hard as Coca-Cola fights for attention."

The best political graphics today exist on the cusp of art and graphic design. The people responsible often see themselves as both artists and designers. The posters don't look like they were done to express the views of a client, but rather to express the viewpoint of the creator. The work doesn't exhibit the sort of cool professionalism typical of pro bono projects done by design firms. Because the designer and client are one and the same, the designer works without any emotional distance or imposed limitations.

It takes a small, young, committed group like Gran Fury to produce posters like "Sexism rears its unprotected head. Men use condoms or beat it. AIDS kills women." The poster features a color photograph of an erect penis.

"We're not answerable to a government agency that would commission a public-service announcement and then say, 'Tone it down,'" explains McAlpin of Gran Fury.

On the other hand, organizations which lobby for left-of-center political causes have, since many of them started out as radical movements in the 1960s and early 1970s, grown large, mainstream, and cautious. Their approaches are safe, corporate, and designed to reach as wide an audience as possible. They have left the anger behind.

Barbara Kruger, one of the best-known American political artists, works in a style inspired by her years in magazine design. Her pieces appear on billboards and bus shelters funded by the Public Art Fund or other organizations in this country and abroad. In 1989 a poster she made for a major prochoice march in Washington, D.C., was pasted onto the city's walls and fences. It shows a woman's face, divided in two lengthwise, one side a positive photographic image the other side a negative one. The type, white Futura on a red background, says, "Your body is a battleground. Support Legal Abortion, Birth Control and Women's Rights."

Kruger recalls, "When I first found out that there was going to be a march to Washington, I called NOW [National Organization of Women]. I said: 'Can I volunteer my services?' They never called me back. And then I called NARAL [National Abortion Rights Action League]. And they were nicer, a little hipper. But forget it. They just said: 'Well, we have someone that we use pro bono.' You know, ads with pictures of the Statue of Liberty… And finally I just got frustrated and I did it myself, and I and my students at the Whitney were out till five o'clock in the morning for about a week, putting those posters up."

Later that year a public-relations firm which operates in the art world approached NARAL. The firm offered to raise money for NARAL with an auction. They asked Kruger to create a poster for that auction. "I did another 'Your Body Is a Battleground' poster for them. The PR firm brought NARAL my image, and the people at NARAL said: 'It's too strong. We don't want to

use it.' So I said: 'Could you please tell them that the Right is using pictures of fetuses? What is so strong?' It was a picture of a woman's face. What were they thinking? And finally they got through to Kate Michaelman [the president of NARAL] and she said, 'It's wonderful. Let's do it.'"

Kruger's poster was subsequently run in the Op-Ed section of the *New York Times*. However the word "body" was deemed too strong for that newspaper's readers–too confrontational for day-time discourse–and the image was run with the words, "You are a battleground."

Another battleground is New York City's East Village, where Anton Van Dalen, Eric Drooker and others have, like the WPA artists of the 1930s, developed a powerful, expressive style of graphics–their own version of social realism–in prints and stencils which protest the injustices they see outside their doors. Their works deal with homelessness, police brutality, drugs and gentrification. The East Village, for a few years, was New York's up-and-coming fashionable neighborhood. Hip art galleries, coupled with real-estate development, attracted affluent, young residents to a poor, tough, troubled neighborhood. The East Village became a focal point for a great deal of grass-roots political activity.

World War 3, a collectively edited, political comic book, is one product of East Village politics. In issue number fifteen, Seth Tobocman used his high-contrast, hard-edged drawing style to tell the story of a riot in Tompkins Square Park, a shabby urban park which became the stage for a long conflict between the homeless who camped in the park, the young anarchists who allied themselves with the homeless, and the New York City Police Department, which ultimately shut the park down. Often graphics done for *World War 3* become street posters, and street poster artists, in turn, pub-

lish their work in *World War 3*.

Another East Village collective called Bullet took over a vacant, city-owned building in the East Village and turned it into a home. When not struggling to connect sewage lines so they could have an indoor toilet, they set up a performance and exhibition space and once covered a whole wall on the street with bright, forceful posters on topics like AIDS and homelessness.

The last decade has produced some masters of political graphics, such as Kruger and Gran Fury. Another leader is Robbie Conal, a Venice, California-based artist whose posters feature vicious caricatures of Bush, Quayle, Jessie Helms and other political figures. They are pasted up late at night in cities around the United States by dedicated volunteer brigades. The Guerrilla Girls, a New York-based collective of anonymous artists, have been protesting sexual and racial discrimination among museum and gallery curators for years. They have recently branched out to address issues of war and censorship.

In San Francisco screen printer Jos Sances adjusts his style to match the issue. His works range from the crudely expressionistic "Piss Helms" (see page 18), to a colorful, cartoonish account of Colonel Sanders's audience with the pope, to a tense realism on a poster supporting improved benefits for schoolteachers. "Screen printing was a medium that could give me a voice," Sances writes in the catalog for a retrospective of his work.

The roster above could go on and on, listing the skilled artists who are making political posters to vent their outrage and give them a sense that they are, in some way, effectively addressing the problems which anger them. And then there are those who have anger but fewer skills. The city's walls and utility poles are covered with the homemade

13

posters that look the way such tracts have looked for decades. It's as if there is a style dictated by the use of the photocopier that is as coherent as any aesthetic from the world's famous design academies. Much of it is so raw and so ephemeral that it's hard to think about it as design. Xeroxed posters are often so gray that they almost seem as if they are a part of the poles to which they're affixed.

Design isn't the right word to categorize these flyers. They are more primitive than that, more a product of reflex. Posters are supposed to shout. But these little posters whisper. They are like the drug dealers who quietly list the names of their wares as you walk by; sometimes they speak so softly you can't be sure you heard anything at all. "Worship the yuppie god," murmurs one distributed by a person or organization called Mutant.

As daytime discourse gets thinner and more banal, year by year, as fewer genuine sentiments or opinions are voiced by politicians, and bold political statements vanish from mainstream media, street posters are becoming the one medium in which controversial opinions can find a general audience. In China political posters were a way around official censorship. Here they sidestep a less official set of restrictions: those having to do with commercial expedience.

Political posters can be read as an expression of frustration from artists, designers and regular people trying to transform a political system that seems thoroughly insulated from individual action, a system that seems moribund. The posters that appear on the walls of our city in the night can spark real political debate. Maybe night discourse is the last form of political debate.

"You need to seize authority," says Gran Fury member McAlpin. "The way we started was with Xerox machines. If you're angry enough and have a Xerox machine and five or six friends who feel the same way, you'd be surprised how far you can go with that."

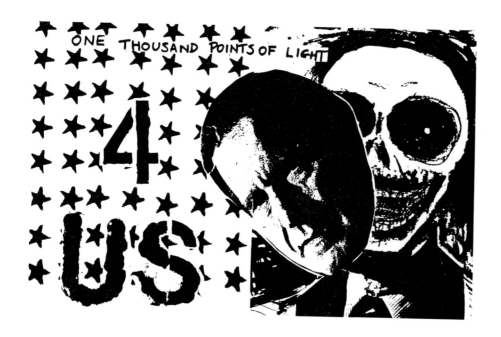

One Thousand Points of Light
Scott Cunningham, 1991

14

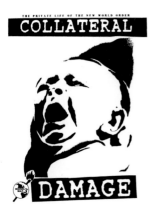

Collateral Damage
Scott Cunningham, 1991
World War 3, New York

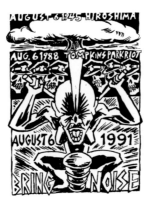

Bring Noise
Seth Tobocman, 1991
Tompkins Park Riot

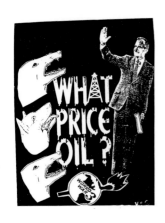

What Price Oil?
Vinnie Salas, 1991
World War 3, New York

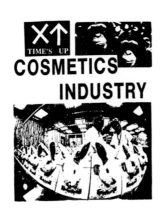

Cosmetics Industry
Anonymous, 1989
Time's Up, New York

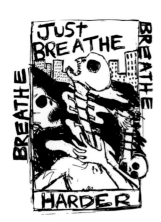

Breathe Just Breathe Harder
Scott Cunningham, 1991

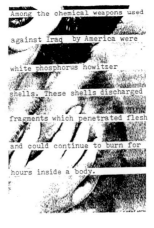

Among the Chemical Weapons…
Anonymous, 1991
Cheap Art, New York

IS IT OBSCENE

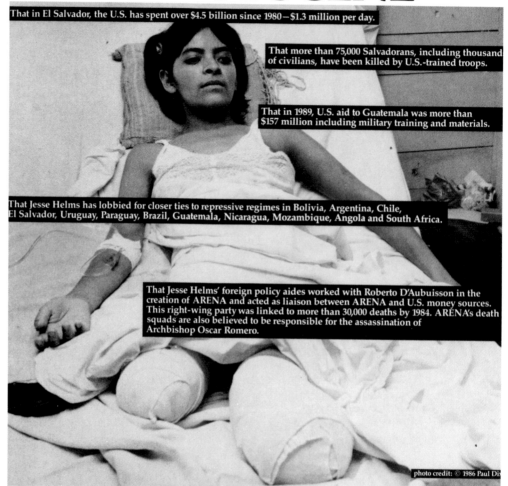

That in El Salvador, the U.S. has spent over $4.5 billion since 1980—$1.3 million per day.

That more than 75,000 Salvadorans, including thousand of civilians, have been killed by U.S.-trained troops.

That in 1989, U.S. aid to Guatemala was more than $157 million including military training and materials.

That Jesse Helms has lobbied for closer ties to repressive regimes in Bolivia, Argentina, Chile, El Salvador, Uruguay, Paraguay, Brazil, Guatemala, Nicaragua, Mozambique, Angola and South Africa.

That Jesse Helms' foreign policy aides worked with Roberto D'Aubuisson in the creation of ARENA and acted as liaison between ARENA and U.S. money sources. This right-wing party was linked to more than 30,000 deaths by 1984. ARENA's death squads are also believed to be responsible for the assassination of Archbishop Oscar Romero.

photo credit: © 1986 Paul Di

JESSE HELMS
DOESN'T THINK SO.

Is It Obscene? Jesse Helms Doesn't Think So.
Gina Gilmour (designer), Paul Dix (photographer), 1990
Published by North Carolina Senate Vote '90, "not authorized by any candidate"

16

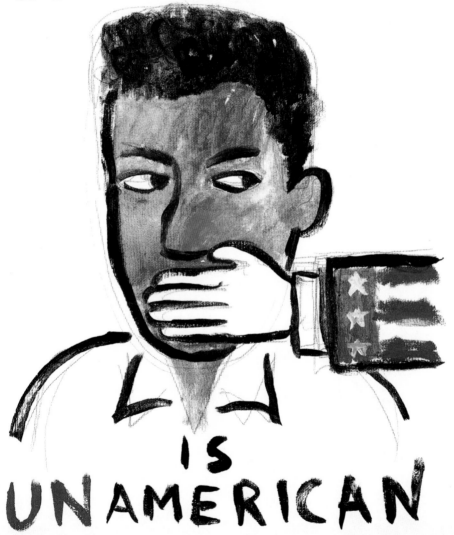

CENSORSHIP IS UNAMERICAN

*Censorship Is
Unamerican*
Josh Gosfield, 1990
Commissioned by Virgin
Records as an expression of
social conscience

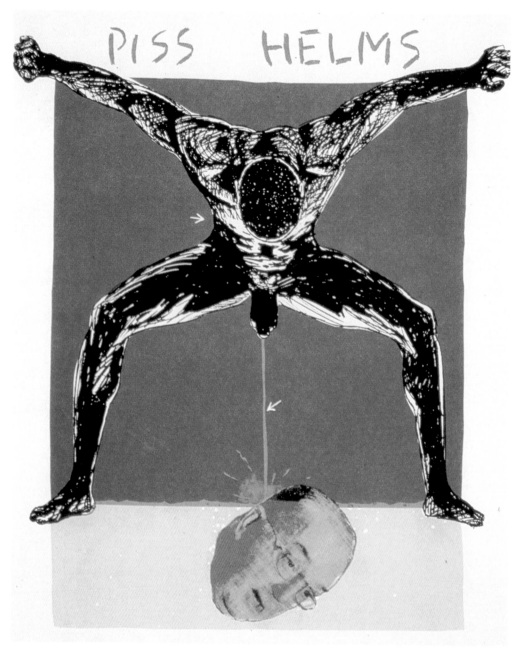

Piss Helms
Jos Sances, 1989
This silkscreen print was originally done for the San Francisco Art Commission Gallery exhibition, "What's Wrong with This Picture?: Artists Respond to Censorship," but was rejected for being too strong. The artist "wheat pasted" it in front of the gallery, embarrassing the curators to include it in the show.

18

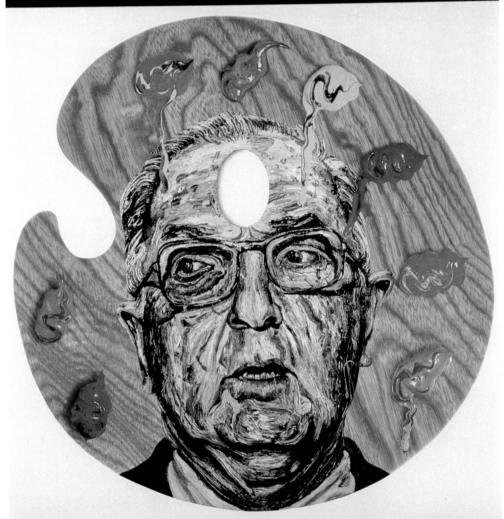

ARTIFICIAL

ART OFFICIAL

Artificial/Art Official
Robbie Conal, 1990
Poster criticizing Jesse Helms for being the point man in the cultural civil war. Six thousand posters (half of them with the slogan, "Holy Homophobia!") were distributed throughout the country to galleries and activist groups. A similar billboard posted in North Hollywood was removed and then reinstated by the billboard company, 3M National.

19

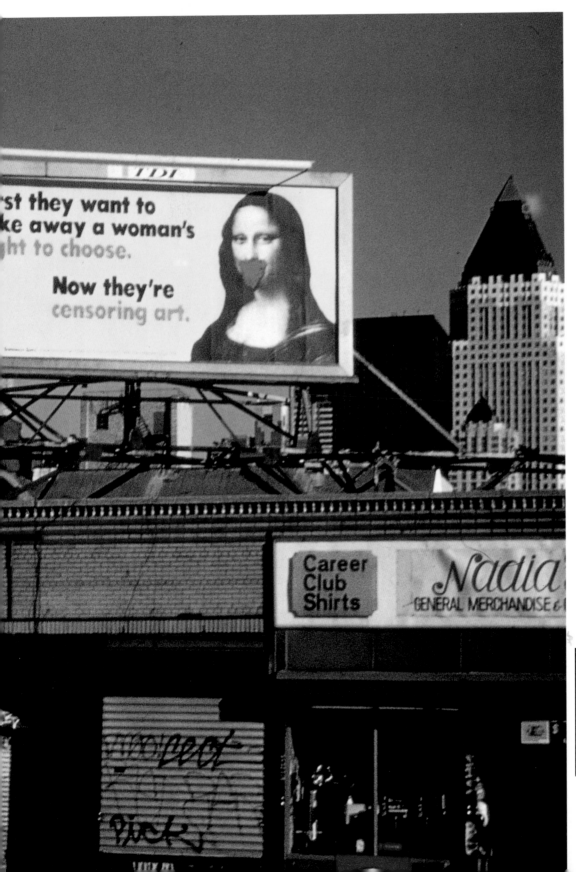

First they want to take away a woman's right to choose. Now they're censoring art.
Guerrilla Girls, 1991
One of ten billboards posted in New York City, sponsored by the Public Art Fund for its city-wide exhibition, "PSA: Public Service Art," from February to March 1991

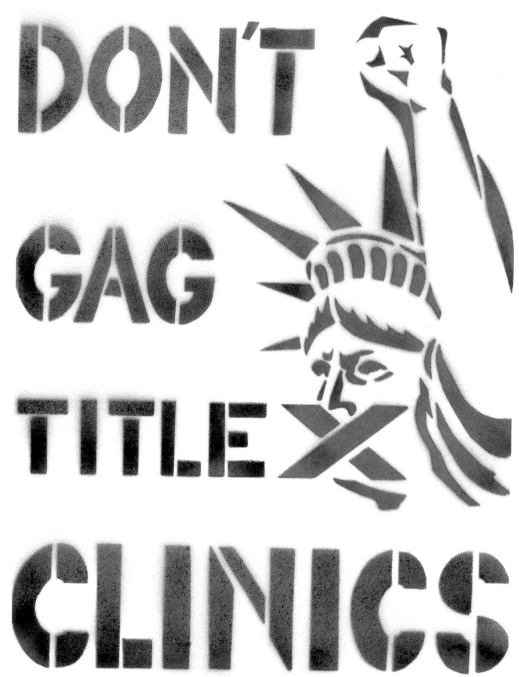

Don't Gag Title X Clinics
Sabrina Jones, 1990
Used as hand-held placard and
wall poster in conjunction with
WHAM's (Women's Health
Action and Mobilization) 1990
march on the Federal Building
in New York City and sit-in at
the Department of Health and
Union Services

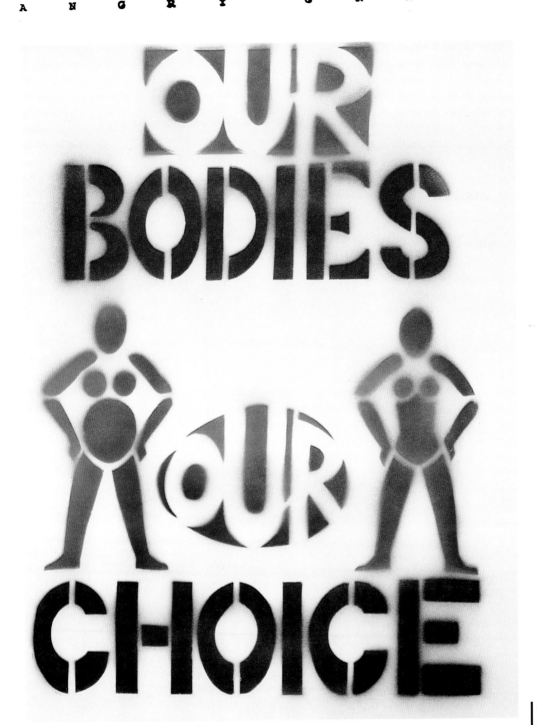

Our Bodies Our Choice
Sabrina Jones, 1990
Published for WHAM
(Women's Health Action
and Mobilization), New York;
used in counterdemonstrations
against anti-abortion groups
trying to close down abortion
clinics

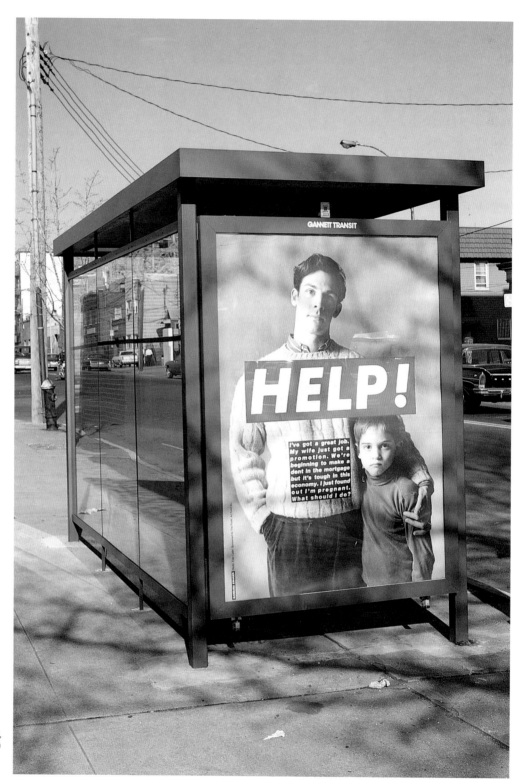

Help
Barbara Kruger (artist),
Fran Collin (photographer),
1991

Three posters for a hundred
shelters in New York City,
sponsored by the Public Art
Fund for its citywide exhibition,
"PSA: Public Service Art," from
January to March 1991.
(installation photograph by
Timothy P. Karr)

24

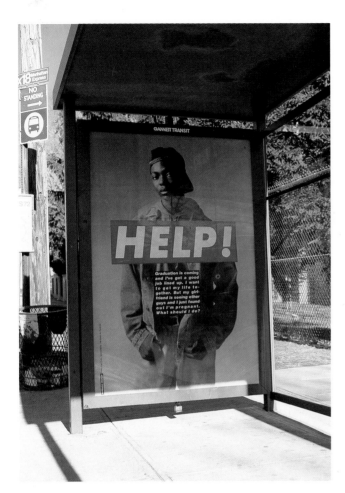

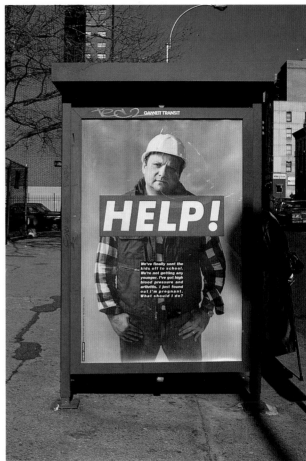

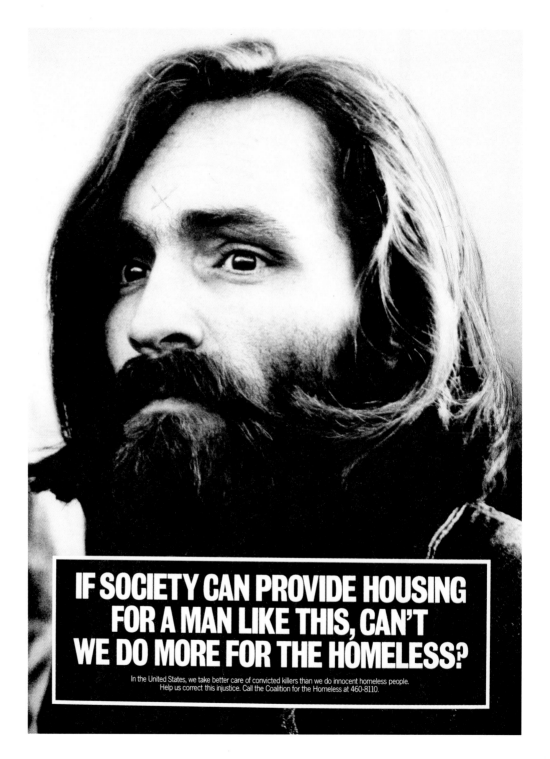

IF SOCIETY CAN PROVIDE HOUSING FOR A MAN LIKE THIS, CAN'T WE DO MORE FOR THE HOMELESS?

In the United States, we take better care of convicted killers than we do innocent homeless people.
Help us correct this injustice. Call the Coalition for the Homeless at 460-8110.

If society can provide housing for a man like this, can't we do more for the homeless?
Peter Cohen and
Jamie Barrett
(concept and design), 1990
One of four images from a wall-poster campaign by The Coalition for the Homeless, New York

26

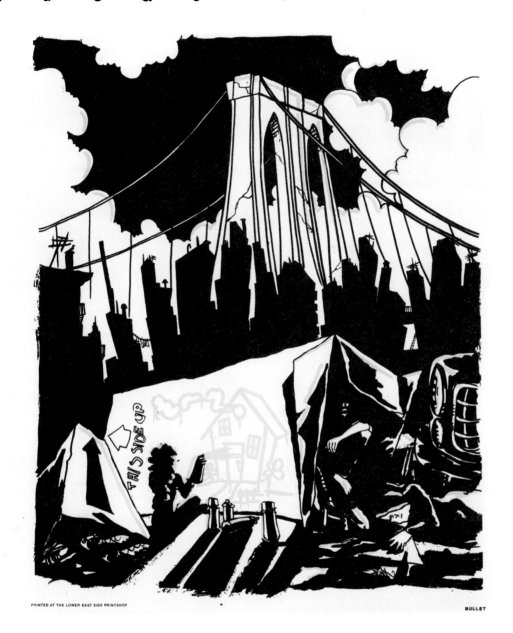

PRINTED AT THE LOWER EAST SIDE PRINTSHOP

BULLET

Under the Brooklyn Bridge
Lady Pink, 1989–91
Poster from the BULLET, an urban artists' collaborative, for its book and street project, *Your House Is Mine*, organized by Andrew Castrucci and Nadia Coën. Printed at the Lower East Side Print Shop

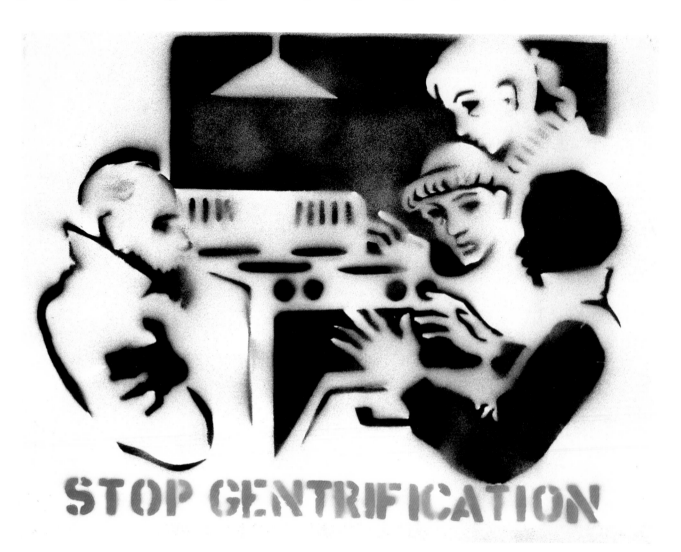

Stop Gentrification
Leslie Bender, 1983
From the "Not for Sale" project antigentrification stencils printed on walls and sidewalks around New York City. Posters were printed and sold to raise funds. Some appeared in the Henry Street Settlement exhibition, "Street Stencils of the Lower East Side." Courtesy of the PAD/D (Political Art Documentation and Distribution) Archive; Barbara Moore and Mimi Smith, archivists. Museum of Modern Art, New York

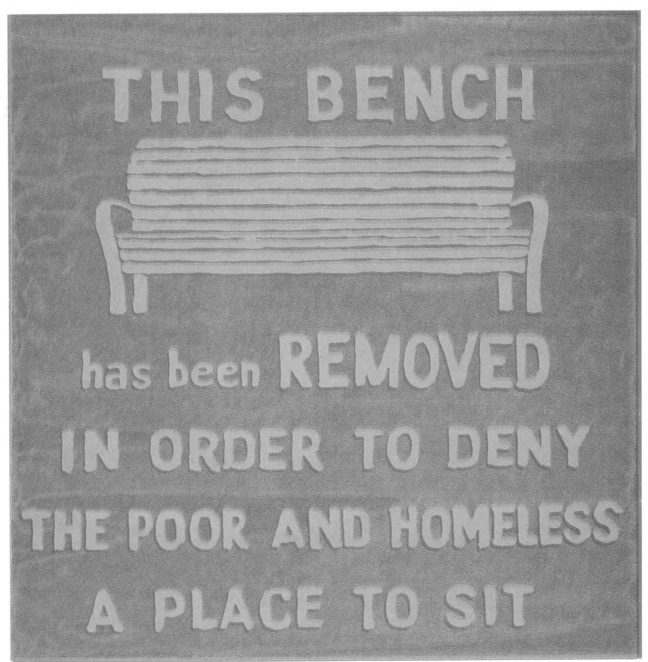

This bench has been removed in order to deny the poor and homeless a place to sit.
David Virgien, 1987
Faux plaques pasted onto bricks where park benches were removed from a Seattle public park

29

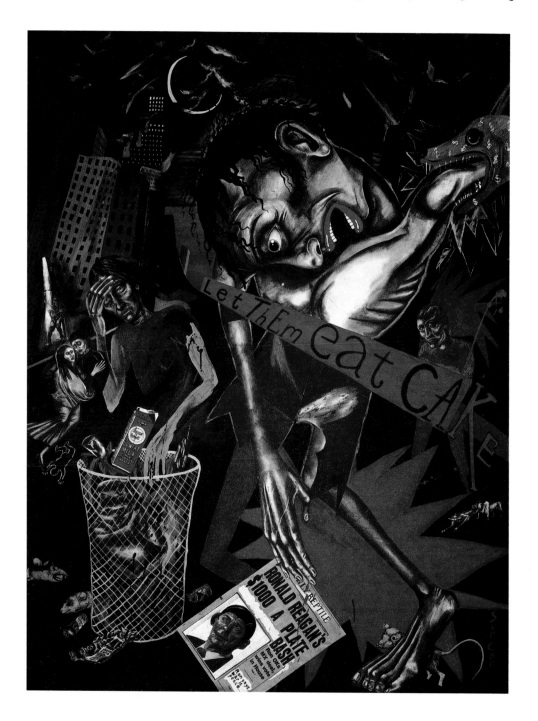

Let Them Eat Cake
Sue Coe, 1985
Poster for "Concrete Crisis,"
a 1987 PAD/D exhibition
protesting the gentrification of
Manhattan's Lower East Side.
Originally published in *Mother
Jones* magazine

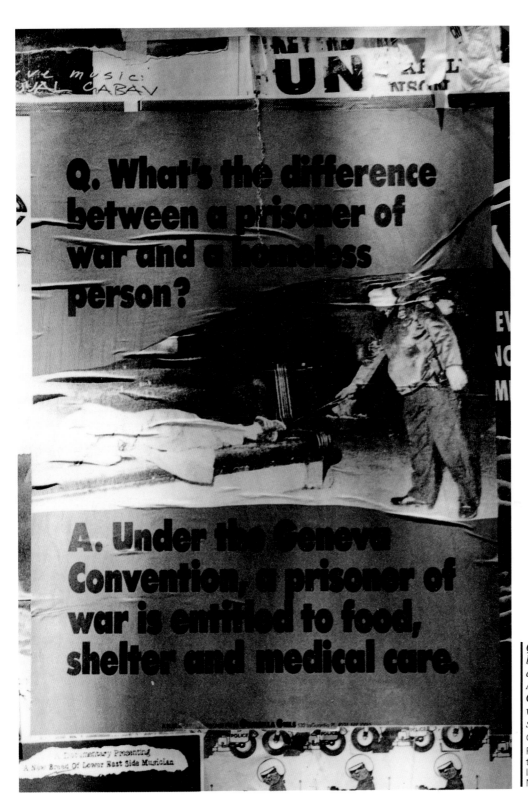

Q: What's the difference between a prisoner of war and a homeless person?
A: Under the Geneva Convention, a prisoner of war is entitled to food, shelter and medical care.
Guerrilla Girls, 1990
Poster responding to the ill treatment of an increasingly large homeless population in New York City

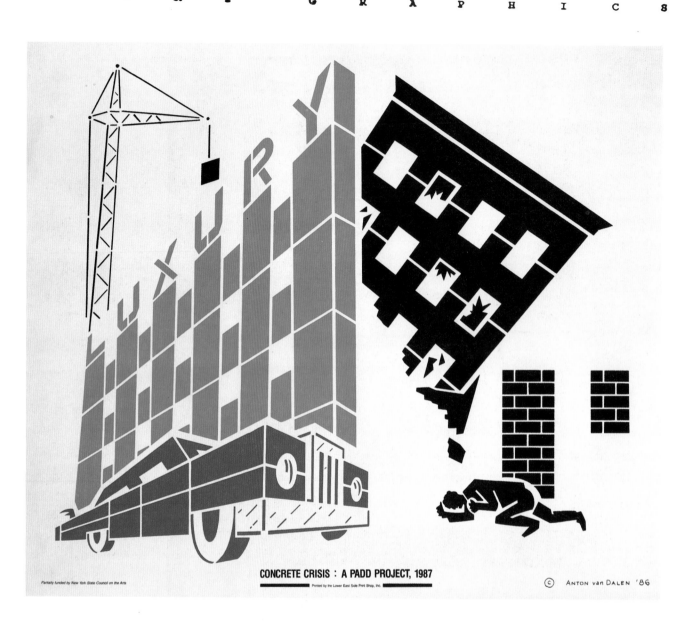

CONCRETE CRISIS : A PADD PROJECT, 1987

Partially funded by New York State Council on the Arts

Printed by the Lower East Side Print Shop, Inc.

© ANTON van DALEN '86

Luxury
Anton Van Dalen, 1986
Poster for "Concrete Crisis," a
1987 PAD/D exhibition
protesting the gentrification of
Manhattan's Lower East Side.
Printed at the Lower East Side
Print Shop

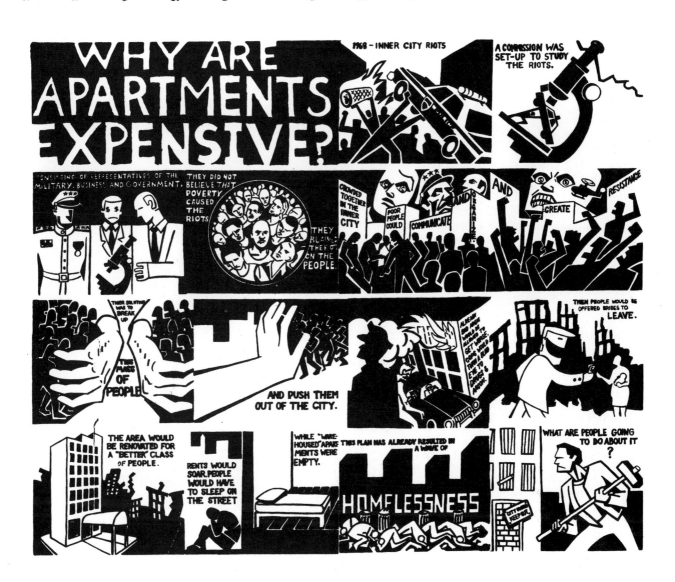

Why Are Apartments Expensive?

Seth Tobocman (artist),
Chuck Sperry (inker),
Frank Morales (writer), 1986

The narrative of this broadsheet is based on an article by Yolanda Ward, a housing-rights activist who was murdered in the 1980s. Originally published in *World War 3* and later made into posters and leaflets distributed by squatters and housing activists. Printed by Black Cat Press, Brooklyn, New York

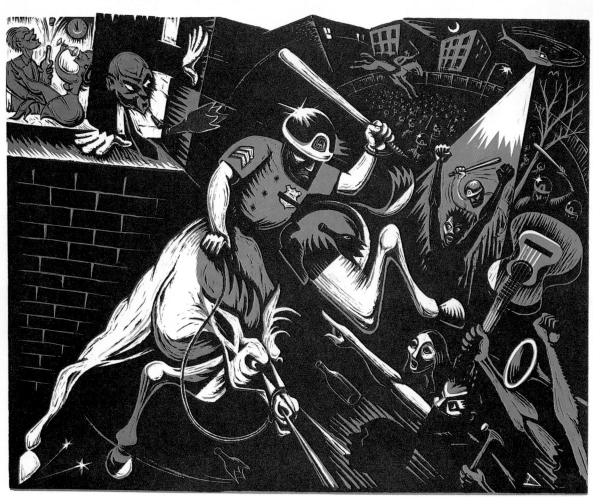

1988 "TOMPKINS SQ. POLICE RIOT" Eric Drooker

Tompkins Square
Community Demands
Eric Drooker, 1988
Published to illustrate a
manifesto of squatters'
demands following the
''Tompkins Square Police Riot''
of August 1988 on Manhattan's
Lower East Side, in which the
park was closed to prohibit the
homeless from gathering

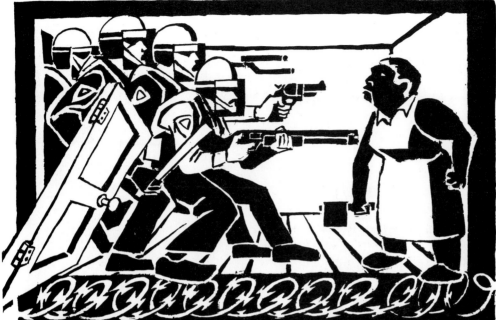

NOV. 1984 A GROUP OF POLICE OFFICERS
WITH SHIELDS, BULLET-PROOF VESTS AND RIOT
HELMETS BROKE DOWN THE DOOR ON 66 YEAR
OLD ELEANOR BUMPURS' BRONX APARTMENT.
SHE TRIED TO DEFEND HERSELF WITH KITCHEN
UTENSILS BUT THEY SHOT HER TWICE AT
POINT BLANK RANGE WITH A SHOTGUN.
THE POLICE HAD COME BECAUSE SHE WAS
LATE IN PAYING HER RENT.

POLICE STATE AMERICA

Police State America
Seth Tobocman, 1984
Commemorating the fatal
shooting of Eleanor Bumpurs by
New York City police; Used by
Harlem Fight Back, Moratorium
on Evictions, Emergency
Coalition Against Marshal
Law, and the Bumpurs family
as a poster (with certain
modifications in copy and
image). Originally published
in *World War 3*

35

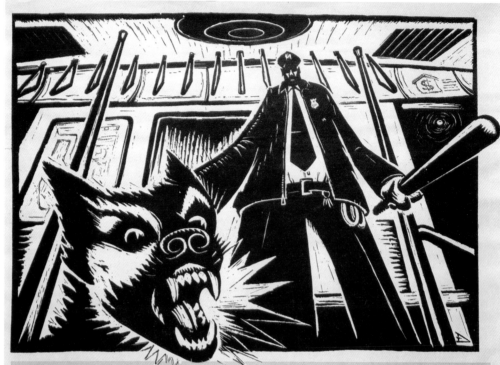

WAKE UP MAN! On your feet! My master wants you out
GET UP and COOPERATE Please don't make me shout
Subways are for men and women travelling to work
Not for the likes of *you* to linger and to lurk
Living down here's illegal, O haven't you heard?
You're only here for "warmth and shelter" *Arf!*
 Don't be absurd
There are many shelters for you upstairs—
 large and out of sight
Now get the fuck outta here man *Woof!* before I bite
It's a dog-eat-dog world, buddy, you know that—don't sob
And don't take it personally fella, I'm just doin' my job
(If I don't bust your ass *I'll* be in trouble,
 my master will get mad
He'll tighten the leash around *my* neck—
 which *really* would be bad)
So MOVE IT now—get lost, take a powder,
 quit bustin' my chops
I said BEAT IT now amigo *DISAPPEAR!*
 before I call more cops
What's that you're doodling there . . . huh?
 Some kind of primitive art?
The law says grafitti is vandalism *Degenerate! grrrrr!*
 Don't you get smart
What's that? . . . you talkin' back? *SHUT UP!*
 Lower your head and bow
Remember young Michael Stewart spoke back . . .
 and look where *he* is now

Heel boy! Do as I say! I'm jury, judge and executioner
I order you up these stairs right now!
 . . . whatcha waitin' 'fer?
That's it, boy, *Keep Moving Keep Moving*
 don't linger in the park
This is Public Property—you can't crash here MOVE IT—
 Bark Bark Bark!
Parks are for people to stroll through while
 looking at the trees
A place where investors can sit in the shade and
 watch their new properties
You are the reason profits are falling
 for landlords who work hard and true
So pack your bags and your rags and be *gone* already—
 you crack addict cannibal you
OUT come on OUT away from that building, get down
 from there on the double!
That building's sealed shut—you're *TRESPASSING*
 now you're in serious trouble
Didn't you hear there are shelters waiting where
 you'll get lots of rest and silence?
Plenty of room for you *there* (ignore the tuberculosis,
 AIDS, crack and violence)
Yeah *yeah!* It's rough all over, don't you think
 I see all the strife?
The point is to *Obey* . . . hey, I'm your best friend
 in this here dog's life

Eric Drooker '90 **BULLET**

Wake Up, Man!
Eric Drooker, 1990
Poster from the BULLET, an
urban artists' collaborative, for
its book and street project,
Your House Is Mine, organized
by Andrew Castrucci and Nadia
Coën. Printed at the Lower
East Side Print Shop

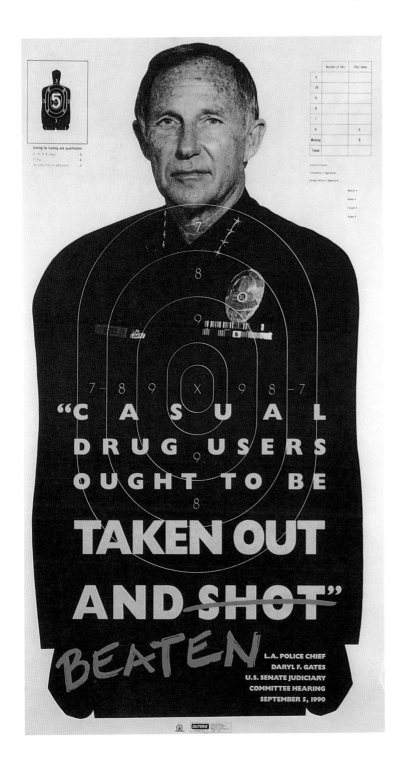

*Casual Drug Users
Ought to Be Taken
Out and Beaten*

Robbie Conal and
Patrick Crowley, 1991

Response to Los Angeles Police
Commissioner Daryl Gates's
statements before the Senate
Judiciary Committee, and his
insensitivity to the documented
civil-rights abuses committed by
L.A. police officers

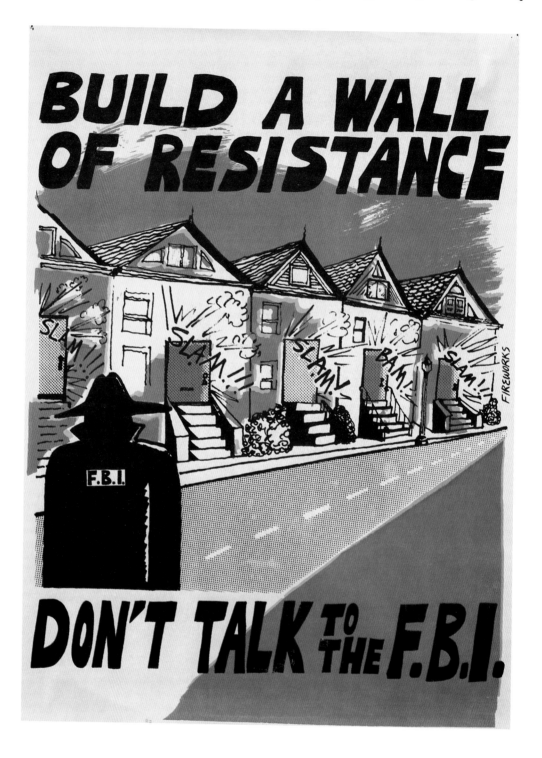

Build a Wall of Resistance. Don't Talk to the FBI

Terry Foreman;
Fireworks Graphics Collective,
San Francisco; 1982

From a series of street posters
protesting FBI and U.S. grand-
jury attacks against the Puerto
Rican independence movement

38

TWO-HEADED MONSTER
DESTROYS COMMUNITY

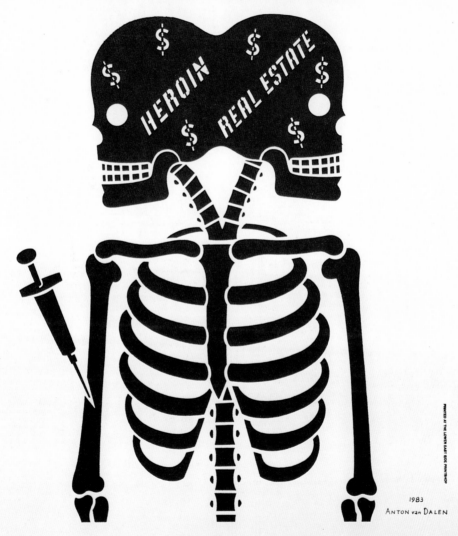

*Two-Headed Monster
Destroys Community*
Anton Van Dalen, 1983
Self-published in response to
the major problems facing
residents of the Lower East
Side, New York. Printed at the
Lower East Side Print Shop

39

Crack House/White House

Peter Kuper and
Seth Tobocman (artists),
Maggie Smith (slogan), 1990

Stencil reproduced with
spray paint throughout New
York City

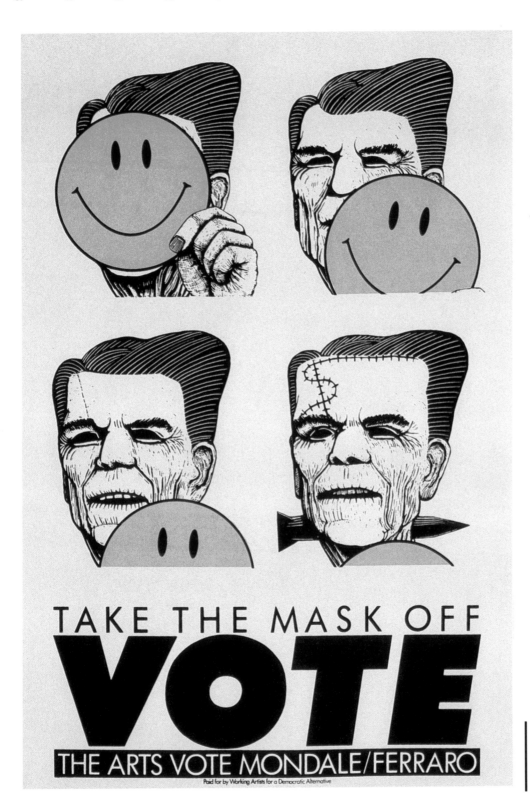

Take the Mask Off
Carl Smool, 1984
Campaign poster sponsored
by Working Artists for a
Democratic Alternative, Seattle,
Washington

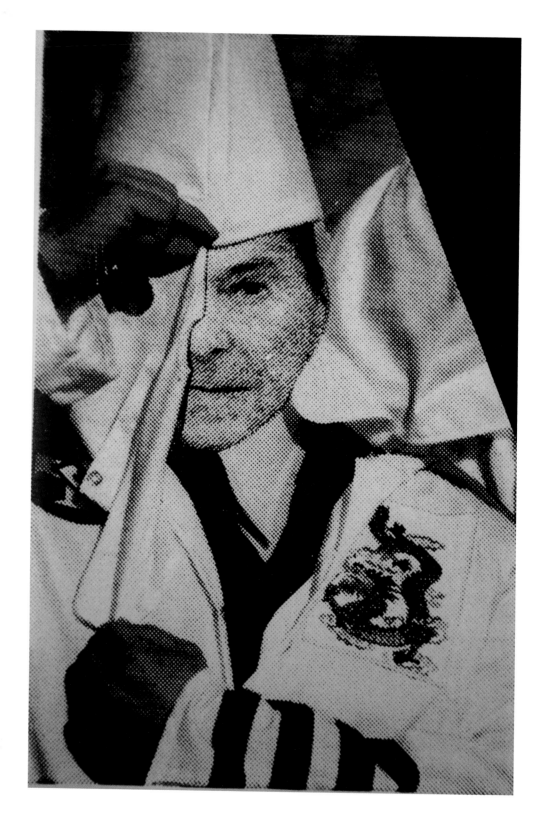

KKK
Steven Oscharoff;
Fireworks Graphics Collective,
Los Angeles; 1984
Poster used to call
attention to KKK support for
Ronald Reagan

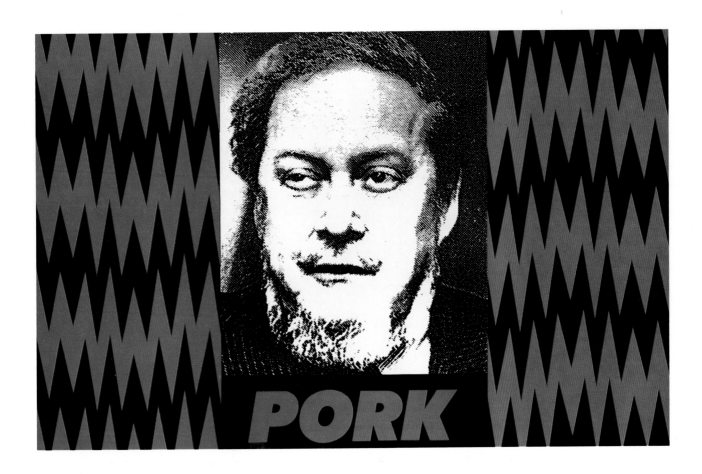

Pork
Donald Moffet;
Street Art,
New York; 1989
Poster protesting Ronald
Reagan's nomination of Judge
Robert Bork to be an associate
justice of the United States
Supreme Court
Courtesy of the PAD/D
(Political Art Documentation
and Distribution) Archive;
Barbara Moore and Mimi Smith,
archivists. Museum of Modern
Art, New York

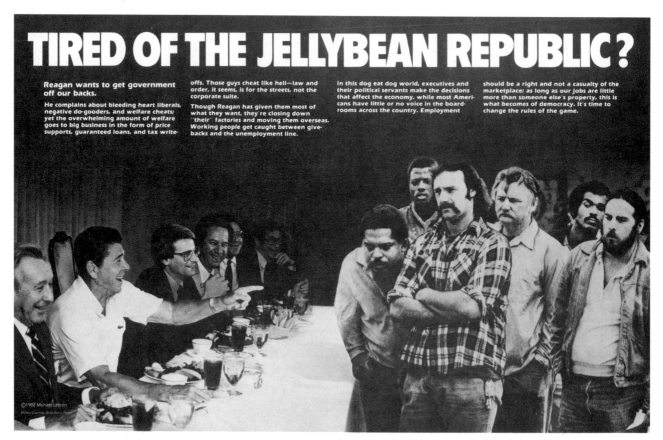

TIRED OF THE JELLYBEAN REPUBLIC?

Reagan wants to get government off our backs.

He complains about bleeding heart liberals, negative do-gooders, and welfare cheats; yet the overwhelming amount of welfare goes to big business in the form of price supports, guaranteed loans, and tax write-offs. Those guys cheat like hell—law and order, it seems, is for the streets, not the corporate suite.

Though Reagan has given them most of what they want, they're closing down "their" factories and moving them overseas. Working people get caught between give-backs and the unemployment line.

In this dog eat dog world, executives and their political servants make the decisions that affect the economy, while most Americans have little or no voice in the board-rooms across the country. Employment should be a right and not a casualty of the marketplace; as long as our jobs are little more than someone else's property, this is what becomes of democracy. It's time to change the rules of the game.

©1982 Michael Lebron

SOME PEOPLE ARE FREE TO CHOOSE, WHILE THE REST OF US FOOT THE BILL.

Tired of the Jelly Bean Republic?
Michael Lebron, 1982
Poster responding to the ill effects of President Reagan's trickle-down economics on the working class

44

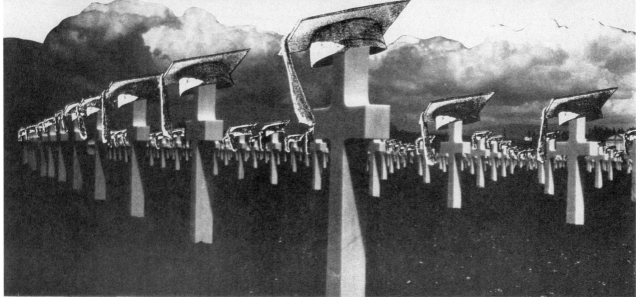

George Bush, "The Education President"

Many poor Americans join the Army to get an education and a better life. If Bush had a _real_ policy for public education, who would fight his wars?

A PUBLIC SERVICE MESSAGE FROM **GUERRILLA GIRLS** 496 LaGuardia Pl. #237, NY 10012

George Bush, "The Education President"
Guerrilla Girls, 1991
Reaction to military buildup in the Gulf

45

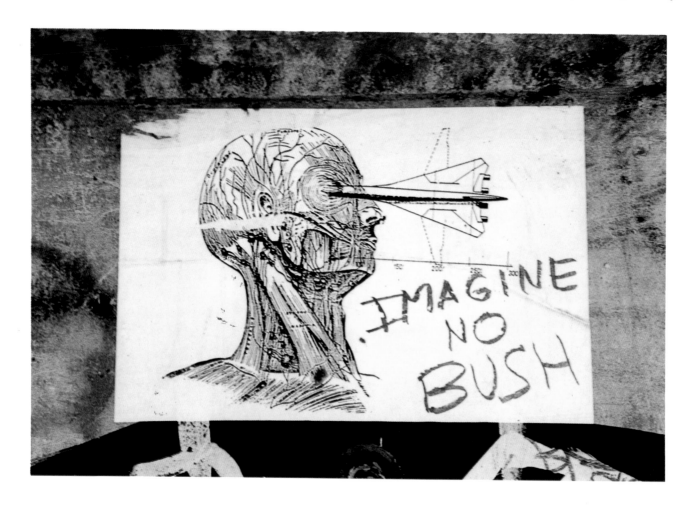

Imagine No Bush
Artist unknown, 1991
Photographed on a wall on
Manhattan's Lower East Side

46

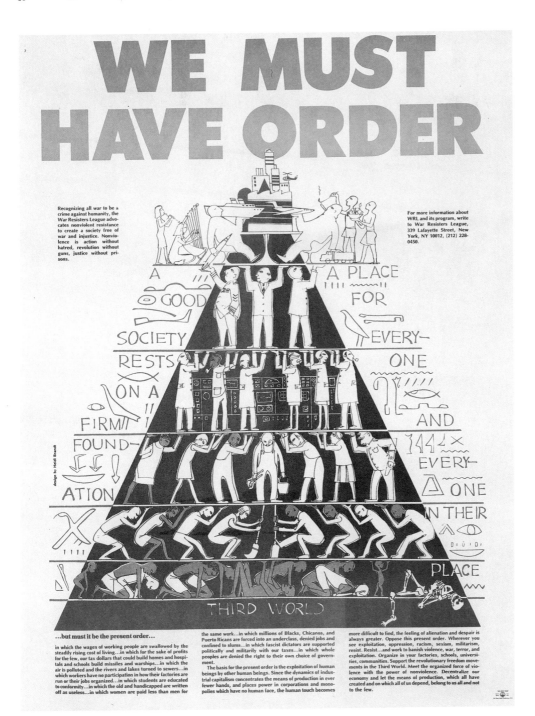

WE MUST HAVE ORDER

Recognizing all war to be a crime against humanity, the War Resisters League advocates nonviolent resistance to create a society free of war and injustice. Nonviolence is action without hatred, revolution without guns, justice without prisons.

For more information about WRL and its program, write to War Resisters League, 339 Lafayette Street, New York, NY 10012, (212) 228-0450.

A GOOD SOCIETY RESTS ON A FIRM FOUNDATION

A PLACE FOR EVERYONE AND EVERYONE IN THEIR PLACE

design by Heidi Brandt

THIRD WORLD

...but must it be the present order...

in which the wages of working people are swallowed by the steadily rising cost of living...in which for the sake of profits for the few, our tax dollars that could build homes and hospitals and schools build missiles and warships...in which the air is polluted and the rivers and lakes turned to sewers...in which workers have no participation in how their factories are run or their jobs organized...in which students are educated to conformity...in which the old and handicapped are written off as useless...in which women are paid less than men for the same work...in which millions of Blacks, Chicanos, and Puerto Ricans are forced into an underclass, denied jobs and confined to slums...in which fascist dictators are supported politically and militarily with our taxes...in which whole peoples are denied the right to their own choice of government.

The basis for the present order is the exploitation of human beings by other human beings. Since the dynamics of industrial capitalism concentrates the means of production in ever fewer hands, and places power in corporations and monopolies which have no human face, the human touch becomes more difficult to find, the feeling of alienation and despair is always greater. Oppose this present order. Wherever you see exploitation, oppression, racism, sexism, militarism, resist. Resist...and work to banish violence, war, terror, and exploitation. Organize in your factories, schools, universities, communities. Support the revolutionary freedom movements in the Third World. Meet the organized force of violence with the power of nonviolence. Decentralize our economy and let the means of production, which all have created and on which all of us depend, belong to us all and not to the few.

We Must Have Order
Heidi Brandt, 1989
Published by the War Resisters League, New York City

DID SHE RISK HER LIFE FOR GOVERNMENTS THAT ENSLAVE WOMEN?

A PUBLIC SERVICE MESSAGE FROM **GUERRILLA GIRLS** 496 LaGuardia Pl. #237, NY 10012

Did she risk her life for governments that enslave women?
Guerrilla Girls, 1991
Photocopy poster protesting the war in the Persian Gulf

48

UNcLE GEORGE
WANTS YOU
to **forget**
Fai LING **BANKs**,
Education,
Drugs, **ai**Ds,
poor health care,
UNEMPLOYMENT, Crime,
Racism,
Corruption...
AND Have A **GOOD WAR**

the Progressive 409 East Main Street, Madison, Wisconsin 53703 USA

STEPHEN KRONINGER ©1991

Uncle George Wants You
Stephen Kroninger, 1991
Self-published and offered free
to peace groups. Subsequently
reprinted and distributed
through the *Progressive*
magazine, Ann Arbor, Michigan

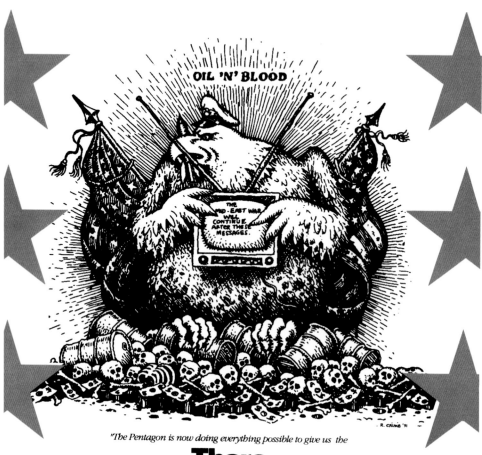

OIL 'N' BLOOD

"The Pentagon is now doing everything possible to give us the

There,

impression that war will come in a tidy little package. ...Now body

America,

bags are 'human remains pouches.' Your sons and daughters and

doesn't that

mothers and fathers will have their faces blown off, their limbs torn

make you

apart, their chests ripped open, but they won't come home in body

feel better?

bags. They'll come home in neat and tidy human remains pouches."

Senator Mark Hatfield, on the floor of the Senate January 12, 1991

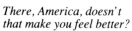

There, America, doesn't that make you feel better?
R. Crumb (illustrator), 1991
Published by *War News*, San Francisco, a tabloid newspaper edited by Warren Hinkle, devoted to stories about the Persian Gulf War not covered in the mainstream press.

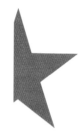

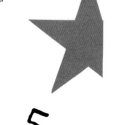

50

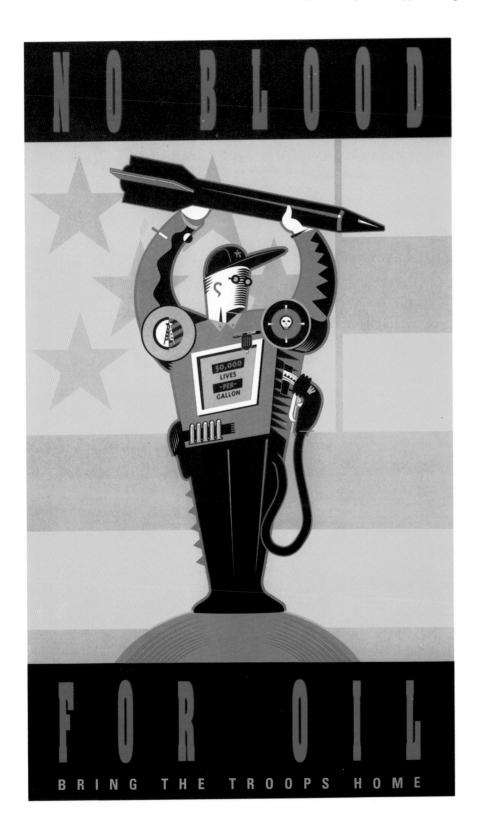

No Blood for Oil
Keith R. Potter (designer),
Steven Lyons (illustrator), 1990
Published by the Emergency
Campaign to Stop the War in
the Middle East. Printed by
Inkworks, Berkeley, California

51

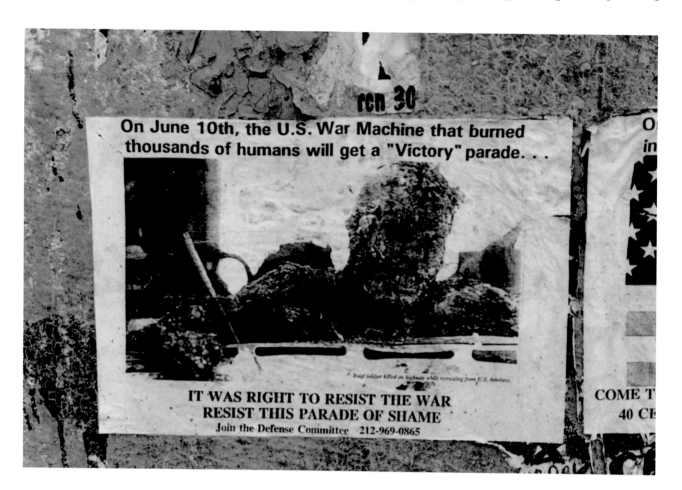

*On June 10th, the U. S.
War Machine that burned
thousands of humans will
get a "Victory" parade…*
Shawn Eichman, 1991
Poster for Defense
Committee to protest the
Desert Storm victory parade
in New York City

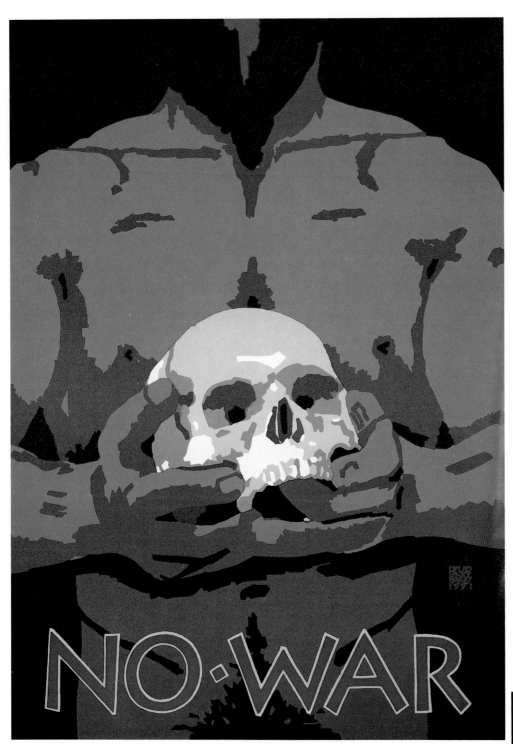

No War
David Lance Goines, 1991
Self-published silkscreen poster
distributed free to peace groups
as a personal response to the
Persian Gulf War. Printed at
Heironymous Press, Berkeley,
California

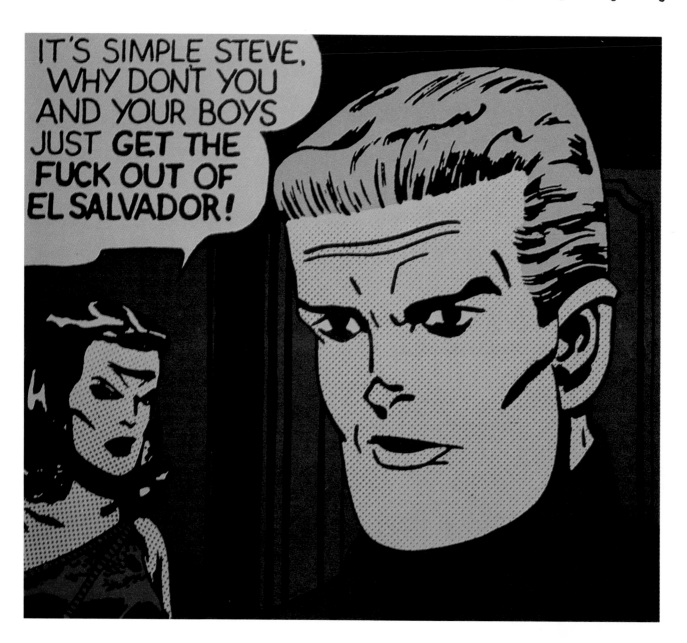

It's simple, Steve…
Herbert Siguenza, 1984
Published by La Raza Graphics
and distributed by the artist
throughout the Bay Area

54

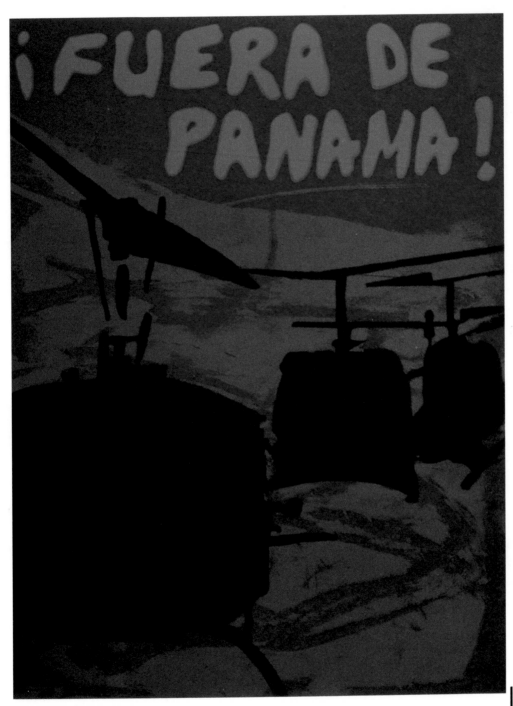

Fuera de Panama
Rupert Garcia, 1989
Color silkscreen published for the benefit of the Committee in Solidarity with the People of El Salvador and the Nicaraguan Information Center. Printed by Jos Sances, Berkeley, California

55

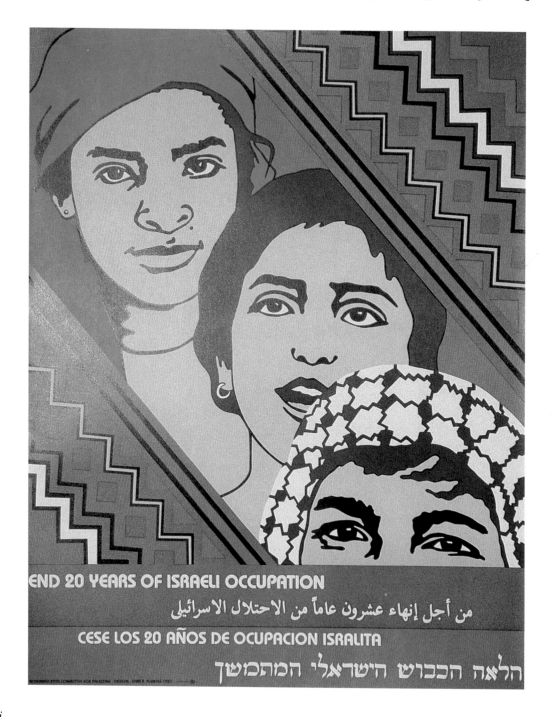

End 20 Years of Israeli Occupation

Juan R. Fuentes, 1987

Response to the continued building of settlements in Israeli-occupied territories in the Middle East

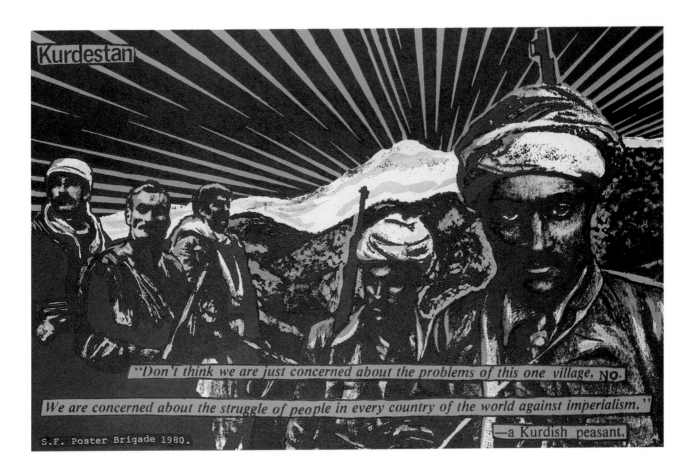

Kurdestan
S.F. Poster Brigade, 1980
Response to Iraqi persecution
of the Kurds. Distributed
through Anti-WW3
Internationalist Art

57

*Free All South African
Political Prisoners Now*
Designer unknown, 1990
Published by the Africa Fund,
New York

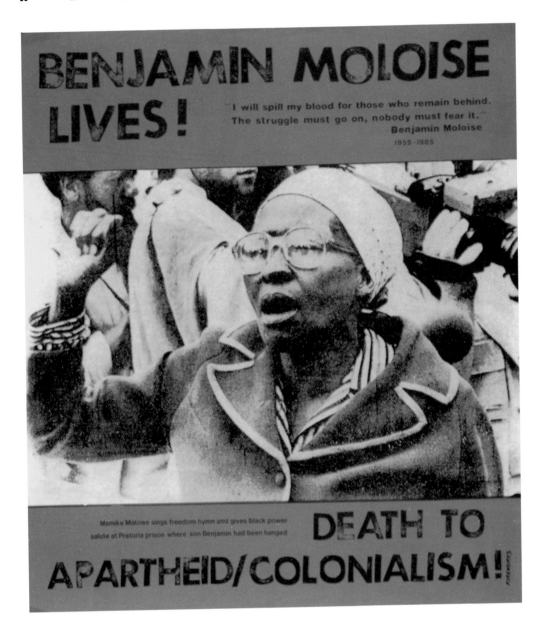

BENJAMIN MOLOISE LIVES!

"I will spill my blood for those who remain behind. The struggle must go on, nobody must fear it."
—Benjamin Moloise
1955-1985

Mamike Moloise sings freedom hymn and gives black power salute at Pretoria prison where son Benjamin had been hanged

DEATH TO APARTHEID/COLONIALISM!

Benjamin Moloise Lives!
Fireworks Graphics Collective, San Francisco, 1985
Poster commemorating the execution of Benjamin Moloise, an African National Congress militant, by the South African government

59

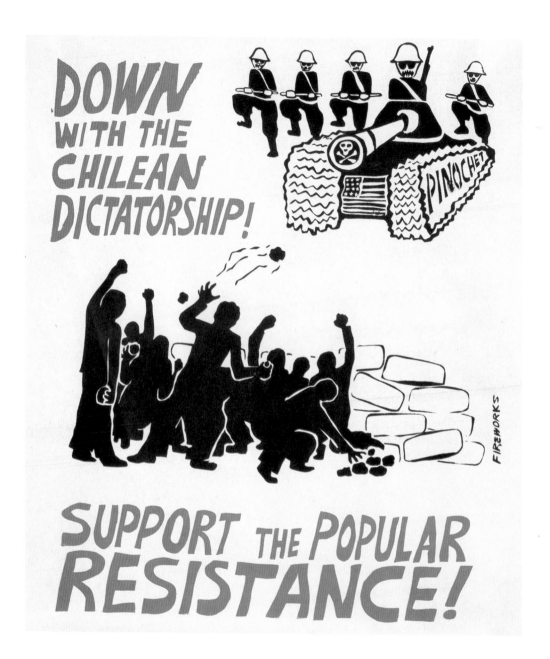

Down with the Chilean Dictatorship

Terry Foreman;
Fireworks Graphics Collective,
San Francisco; 1983

Poster to commemorate the
nineteenth anniversary of
the military coup in Chile

60

¡DESPIERTA BORICUA!

90 AÑOS DE COLONIALISMO YANQUI
¡90 AÑOS DE RESISTENCIA!

¡Fuera la Guardia Nacional Puertoriqueña
de Panamá y Honduras!

Apoya La Lucha del Pueblo Centro Americano!

PUERTO RICO LIBRE

¡NO TE INSCRIBAS NO VOTES!

¡Despierta Boricua!
Robert Cuni, CA. 1990
Published by Black Cat Press,
Brooklyn, New York

No Business As Usual
Designer unknown, 1988
Published by No Business as
Usual, New York Courtesy
of the PAD/D (Political
Art Documentation and
Distribution) Archive;
Barbara Moore and Mimi Smith,
archivists. Museum of Modern
Art, New York

62

No Nukes
Keith Harring, 1982
Self-published and distributed
for free at the 1982 No Nukes
rally in New York City.
Courtesy of the PAD/D
(Political Art Documentation
and Distribution) Archive;
Barbara Moore and Mimi Smith,
archivists. Museum of Modern
Art, New York

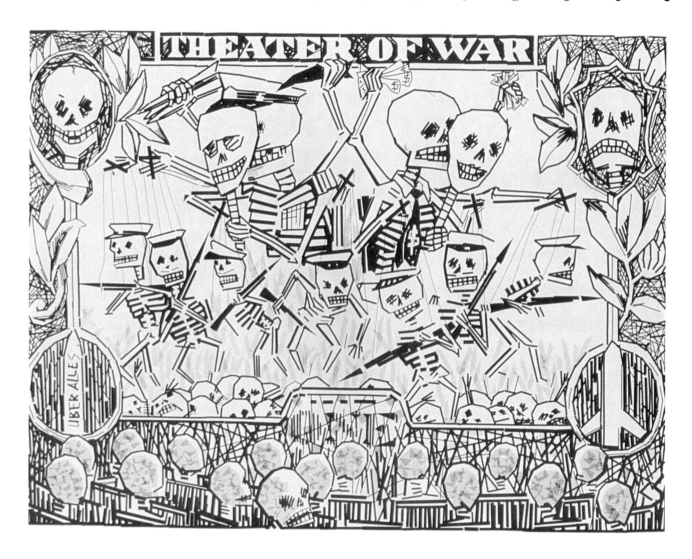

Theater of War
Carl Smool, 1983

Originally published as a
centerfold for the Seattle
magazine, *Northwest Passage*,
which ran an overage used as
posters to protest U.S.
involvement in Central America

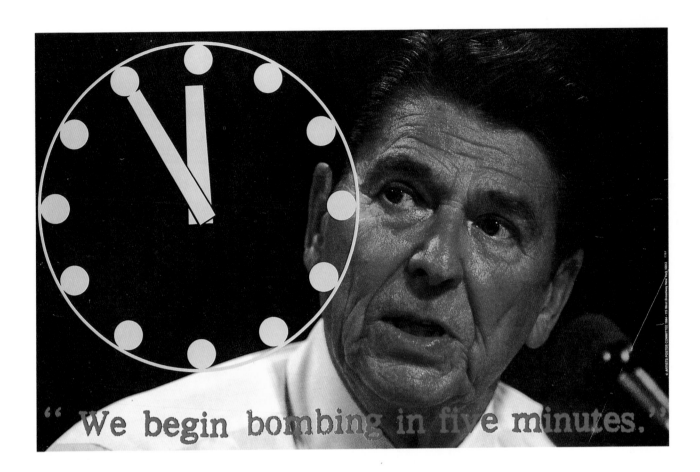

*We begin bombing in
five minutes*
John Hendricks, 1984
Based on a well-publicized
candid comment by President
Reagan. Published by the Artists
Poster Committee, New York

Americans Must Consume Less Fossil Fuel

Americans have an enormous appetite for fossil fuels—coal, oil, and natural gas. We use them to power our cars, heat our homes, and produce most of our electricity. So each time we drive to the mall, watch television, turn on a light, or listen to a CD, we are consuming fossil fuel. And we are consuming more today than ever before.

This growing hunger for fossil fuel is ruining both our environment and our economy. The harmful effects include:

Global Warming. Naturally occurring carbon dioxide (CO_2) and other gases trap heat and keep the Earth warm. But the burning of fossil fuels is releasing trillions of pounds of extra CO_2 into the atmosphere each year. This will likely cause global temperatures to rise. An increase of several degrees could raise sea levels, produce extensive flooding, make droughts more frequent, and disrupt farming. Habitats may shrink as plants and animals struggle to adapt to the rising temperatures.

Acid Rain. Cars, trucks, and coal-burning power plants emit gases that make clouds and rainfall more acidic. This "acid rain" kills trees and poisons lakes and streams.

Air Pollution. The air in many major cities will remain unhealthy unless we reduce automobile and industrial emissions. Air pollution caused by the burning of fossil fuels is responsible annually for tens of billions of dollars in health-care costs.

Oil Spills. Each year, millions of gallons of oil are spilled into rivers, harbors, and oceans, killing fish, birds, and plants and damaging beaches and wetlands.

Dependence on Foreign Oil. The US relies on foreign countries for nearly half its oil. If these countries raise prices drastically, cut off supplies, or become involved in a war, the US could find itself without needed oil.

Trade Imbalance. Each year, Americans buy many foreign products. Unfortunately, we do not sell as many American goods abroad, thereby causing a "trade deficit," which weakens our economy. About 40 percent of the trade deficit can be traced to oil imports.

For all of these reasons, it is essential that we go on a fossil-fuel diet. The well-being of our economy and our environment depends on it.

We Can Diet Without Starving Our Economy

There are two good ways to consume less fossil fuel: energy efficiency and renewable energy.

Energy Efficiency. We can stop wasting energy. The way to do this is to drive cars that use less gas, recycle, insulate our homes, install high-technology light bulbs, and purchase energy-efficient appliances. Governments and businesses can increase efficiency and save money by doing similar things in schools, factories, and office buildings. Utilities can avoid building expensive new power plants by encouraging their customers to adopt efficiency measures. Such actions would save our nation billions of dollars each year and would make us more competitive with Japan, West Germany, and other countries that use energy much more efficiently than we do.

Renewable Energy. Even with improved efficiency, we will need new sources of energy to replace fossil fuels. Solar power, wind, and biomass (plant matter) are three excellent alternatives, because they are inexhaustible, produce little or no pollution or hazardous waste, and pose few risks to public safety. Their use should be expanded immediately. The Union of Concerned Scientists estimates that renewable energy sources could provide up to half of the US's energy needs by the year 2020. However, individuals, businesses, and the government must all work to make this happen.

The Billion Pound Diet is a program of the Union of Concerned Scientists that involves individuals, classes, schools, and groups in the reduction of fossil-fuel use. Together, we will reduce carbon dioxide emissions by one billion pounds over the next year. This program is a first step towards efficient, economic, and environmentally sound energy use. For further information on **The Billion Pound Diet** or energy issues, please contact the Public Education Department, Union of Concerned Scientists, 26 Church Street, Cambridge, MA 02238 (617-547-5552).

ISN'T IT TIME WE WENT ON A DIET?

UNION OF **CONCERNED SCIENTISTS**

PRINTED ON RECYCLED PAPER

Isn't It Time We Went on a Diet?
Designer unknown, 1986
Published by the Union of Concerned Scientists, Cambridge, Massachusetts

Earth Day 1990
Seymour Chwast, 1990
Published by the Earth Day
Rally Committee, New York,
to promote the march and
activities on Earth Day

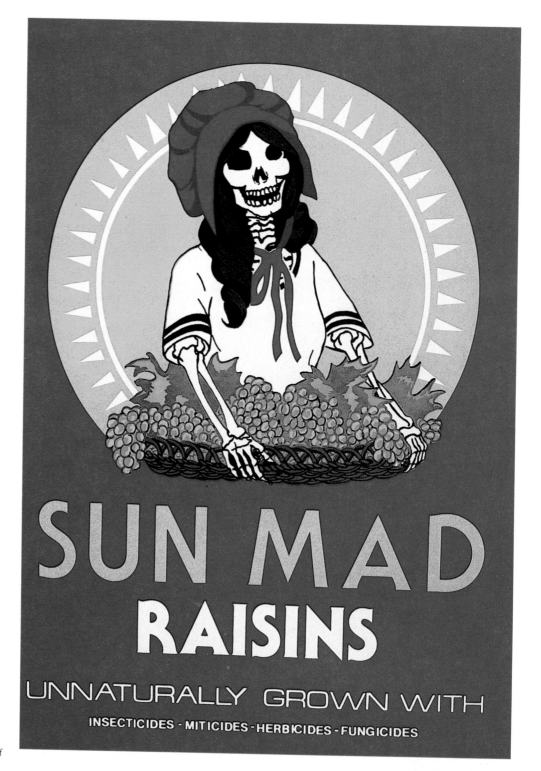

Sun-Mad Raisins
Esther Hernandez, 1981
Self-published in response to the contamination by the makers of Sun Maid Raisins of the water table in the region of California where the artist's family lives and works

68

*The day they devolve
cattle into beefy worms…*
Artist unknown, 1990
Posted on a wall on the
Lower East Side of Manhattan

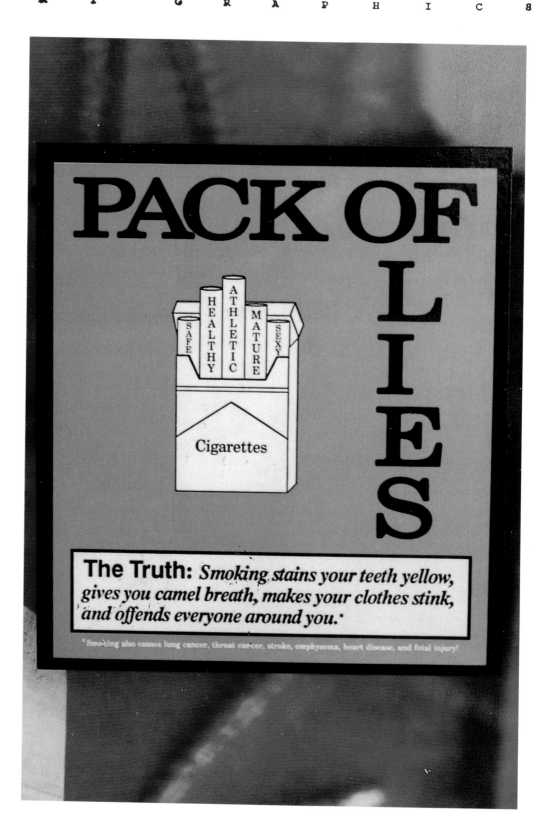

Pack of Lies
Designer unknown, 1990
Pasted over Marlboro
(and other cigarette)
advertisements throughout
New York subway system

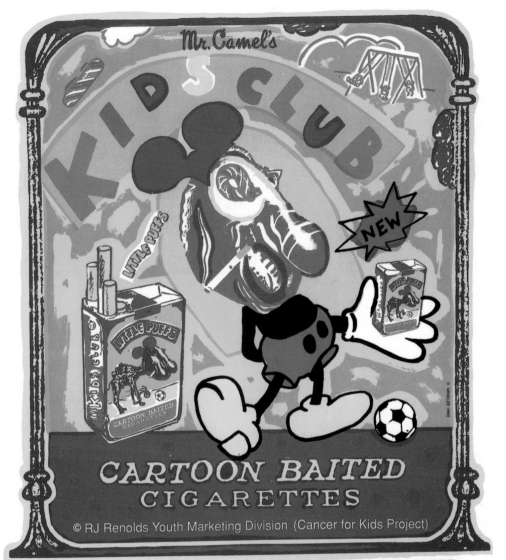

From the series, **THE SEVEN EARLY SIGNS OF CANCER.**
Doctors Ought to Care 5510 Greenbriar, Suite 235 Houston, Texas 77005 713-798-7729

Kids Club
Doug Minkler, 1990
Silkscreens done for DOC
(Doctors Ought to Care),
Berkeley, California, to increase
awareness that the tobacco
industry uses cartoons to sell
cigarettes

71

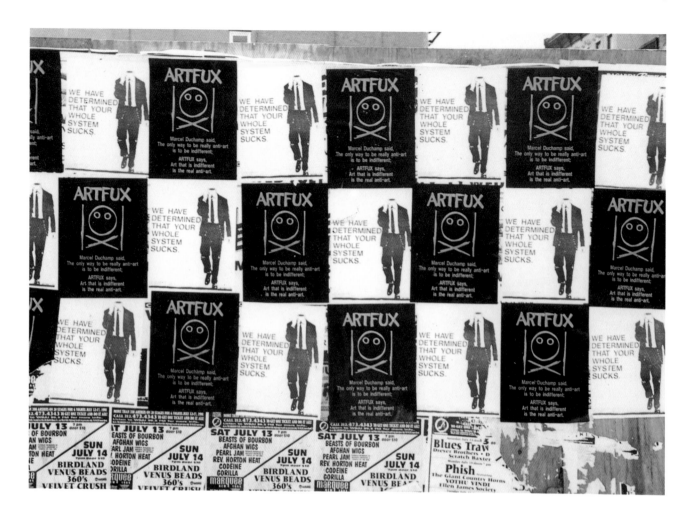

*We Think Your Whole
System Sucks*

Artfux; Jersey City,
New Jersey; 1990

Guerrilla group involved in
street art that includes defacing
liquor and cigarette billboards.
The headless everyman is an
Artfux emblem representing
American alienation and
violence.

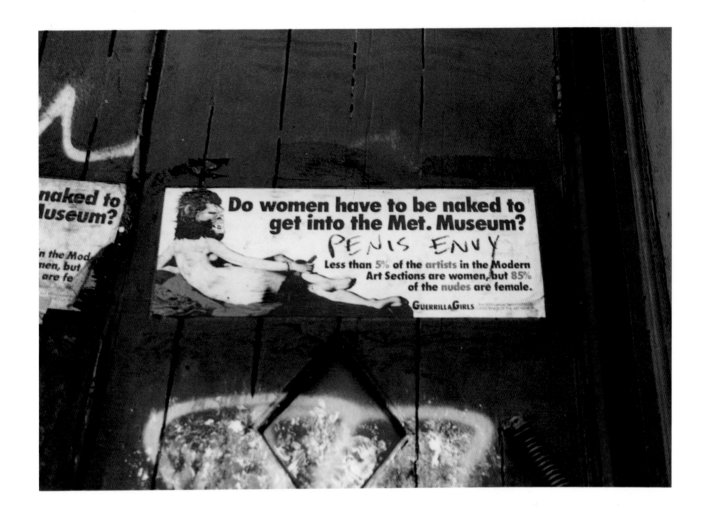

*Do women have to be
naked to get into the
Met. Museum?*
Guerrilla Girls, 1989
Used to increase awareness of
the inequities in the exhibition
of art and artists at New York's
most prestigious museum

73

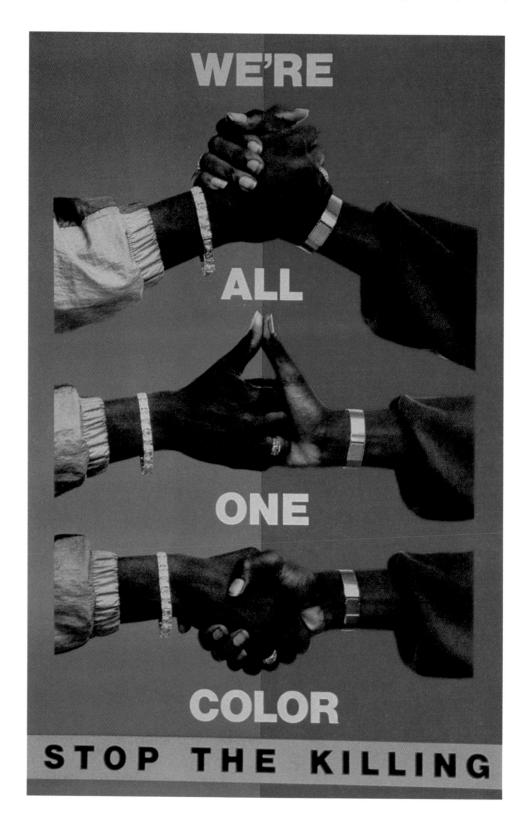

We're all one color
Robbie Conal, Debbie Ross
and Fred Jones (artists),
Al Schaffer (photographer), 1989

This poster denouncing gang
violence in Los Angeles was dis-
tributed for free and posted by
volunteer snipers in cities around
the country.

74

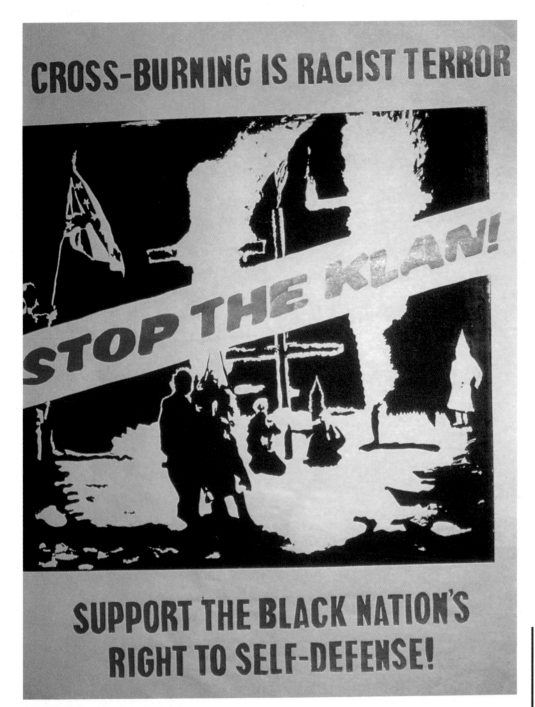

CROSS-BURNING IS RACIST TERROR

STOP THE KLAN!

SUPPORT THE BLACK NATION'S RIGHT TO SELF-DEFENSE!

Stop the Klan
John Brown Anti-Klan Committee and Fireworks Graphics Collective, Los Angeles, 1983
Poster in response to the burning of three crosses by the KKK, Nazis, and the Aryan Nation in the racially mixed Lakeview section of Los Angeles; the first coalition of these three hate groups, which later became the core of the Order, an armed fascist group

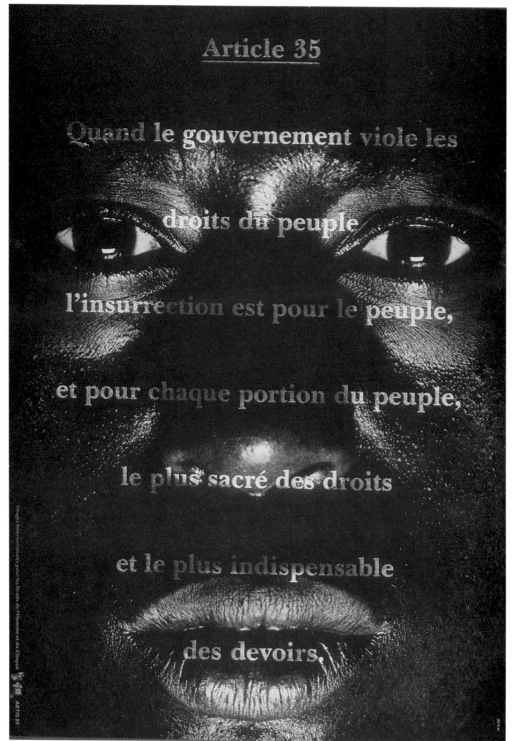

Article 35
Tibor Kalman and
Douglas Riccardi, 1989
Poster commemorating the
anniversary of the Rights of Man
for an exhibition and portfolio
cautioning against human-rights
abuses. Organized by Grapus,
Paris, France

76

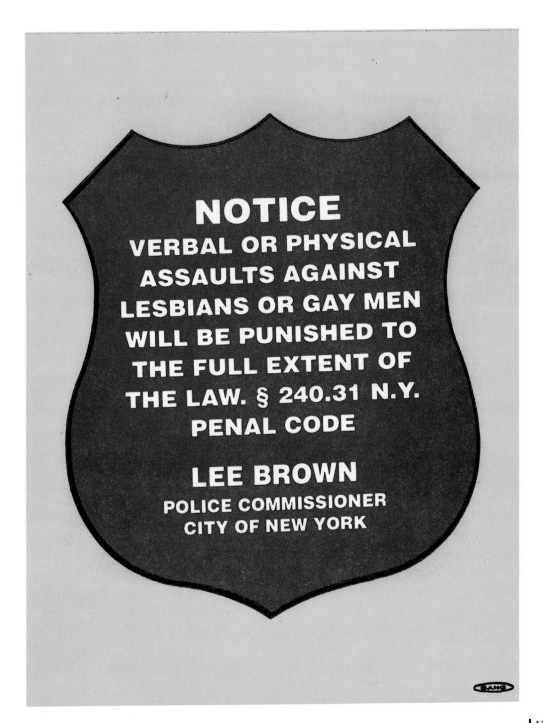

Notice. Verbal or Physical Assaults against Lesbians or Gay Men…
Gang, New York, 1991
Sticker posted around New York City

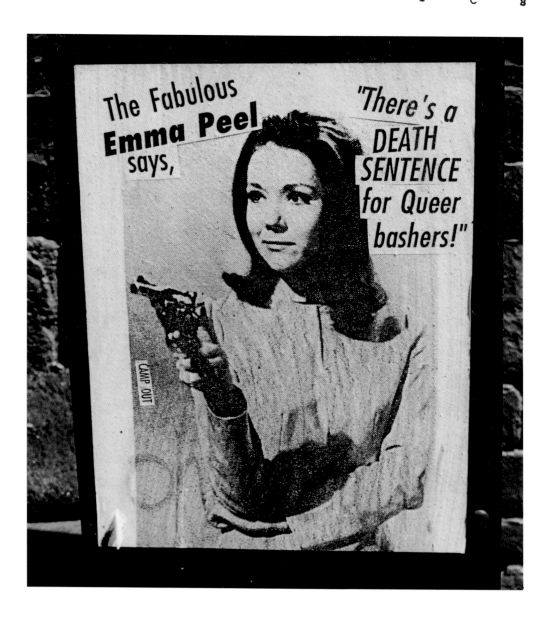

*The Fabulous Emma
Peel Says…*
Camp Out, New York, 1991
Anti-gay-bashing wall poster
produced in response to a rash
of attacks in New York City

78

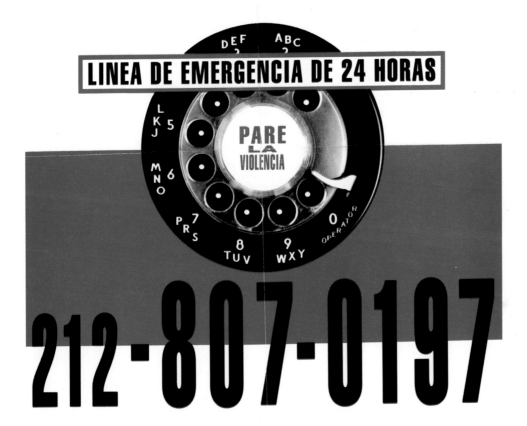

PROYECTO ANTI-VIOLENCIA
Gay y Lesbiana DE NY

DESIGN: BUREAU, N.Y

LINEA DE EMERGENCIA DE 24 HORAS

PARE LA VIOLENCIA

212-807-0197

Llame si Ud. ha sido víctima de la violencia doméstica, asalto sexual, asalto motivado por prejuicio o cualquier tipo de crimen. Llame por información, defensa e consejería. Para documentar el crimen con el proyecto, aunque no quieras hacer la denuncia a la policía. Todos los servicios son gratis y confidenciales.
Proyecto Anti-Violencia Gay y Lesbiana de New York City, 208 W. 13TH ST. NYC 10011

*Protecto Anti-Violencia
Gay y Lesbiana*
Bureau, N.Y. (designer), 1990
Published in English and Spanish
by the Gay and Lesbian
Antiviolence Project, New
York, in response to increasing
attacks on gays

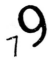

*I am a lezzie butch
pervert…*
Fierce Pussy, New York, 1991
Photocopy wall poster
photographed in New
York City

Does your mama

know you're out?

Does your mama know you're out?
Fierce Pussy, New York, 1990
Photocopy wall poster sniped around New York City

VISUALIZE THIS.

Nancy Burson in collaboration with Kunio Nagashima, Program Resources Inc./DynCorp at the National Cancer Institute–Frederick Cancer Research and Development Center © copyright 1991. Both images were taken with the S-4000 Scanning Electron Microscope courtesy of Hitachi Scientific Instruments. Art Direction by Vincent Gagliostro. Made possible by a grant from Creative Time Inc.

Visualize This
Nancy Burson and
Kunio Nagashima (artists),
Vincent Gagliostro
(art director), 1991
Poster for the GMHC
(Gay Men's Health Crisis)
showing healthy and HIV T-cells

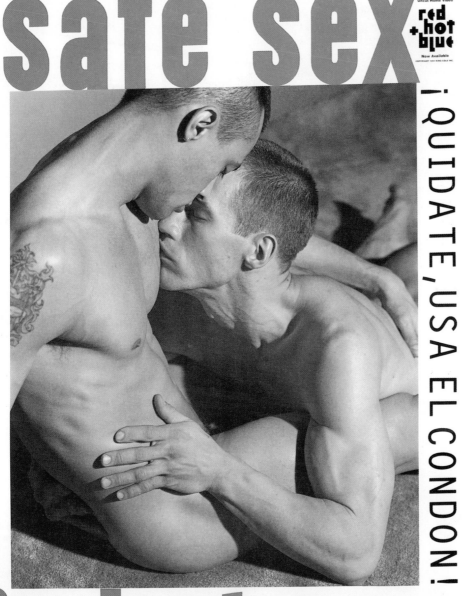

safe sex

USE A CONDOM EVERYTIME

¡QUIDATE, USA EL CONDON!

is hot sex

Uncut Home Video
red hot + blue
Now Available

Safe Sex Is Hot Sex
Steven Meisel (photographer),
Anneliese Estrada
(creative director),
Helene Silverman (designer),
1991

Poster for the "Red Hot and
Blue" project, New York, sold by
ACT-UP to help raise funds

83

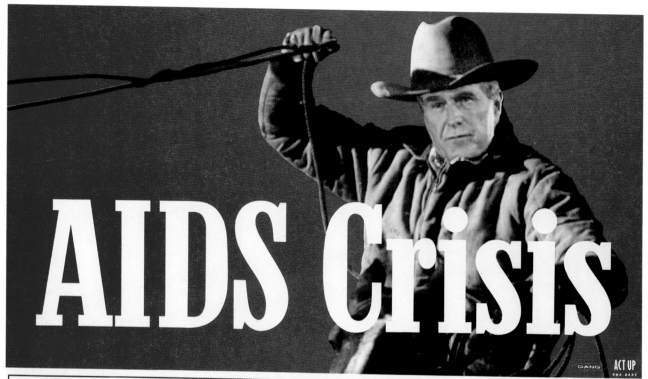

WARNING: While Bush spends billions playing cowboy, 37 million Americans have no health insurance. One American dies of AIDS every eight minutes.

AIDS Crisis
Gang, New York, 1990
Poster for ACT-UP protesting
President Bush's indifference
to AIDS victims

84

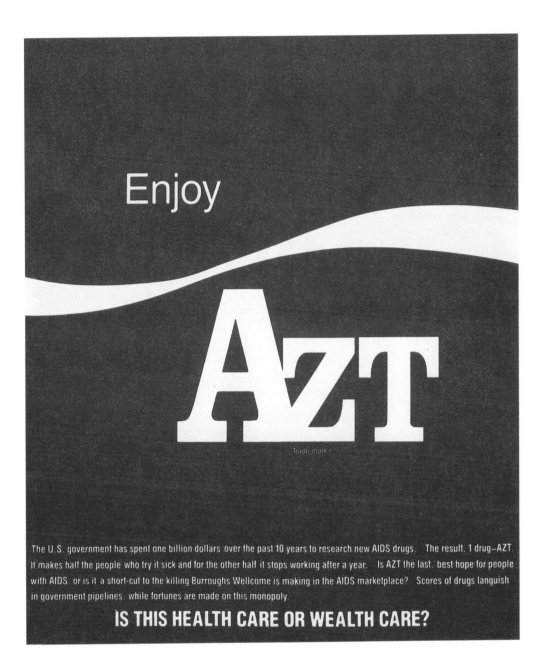

Enjoy

AZT

Trade-mark ®

The U.S. government has spent one billion dollars over the past 10 years to research new AIDS drugs. The result, 1 drug—AZT.
It makes half the people who try it sick and for the other half it stops working after a year. Is AZT the last, best hope for people
with AIDS, or is it a short-cut to the killing Burroughs Wellcome is making in the AIDS marketplace? Scores of drugs languish
in government pipelines, while fortunes are made on this monopoly.

IS THIS HEALTH CARE OR WEALTH CARE?

Enjoy AZT
Vincent Gagliostro and
Avram Finkelstein, 1989
Poster from the *BULLET*, an
urban artists' collaborative, for
its book and street project, *Your
House Is Mine*, organized by
Andrew Castrucci and Nadia
Coën. Printed at the Lower
East Side Print Shop

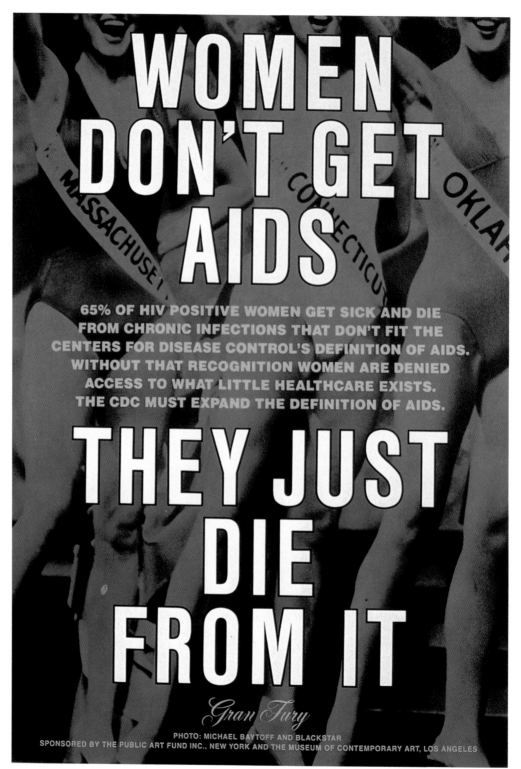

Women Don't Get AIDS, They Just Die from It
Gran Fury (designer), Michael Baytoff, Blackstar (photographer), 1990
Bus-shelter poster sponsored by the Public Art Fund, New York, and the Museum of Contemporary Art, Los Angeles

86

KISSING DOESN'T KILL: GREED AND INDIFFERENCE DO.

CORPORATE GREED, GOVERNMENT INACTION, AND PUBLIC INDIFFERENCE MAKE AIDS A POLITICAL CRISIS.

Kissing Doesn't Kill. Greed and Indifference Do.
Gran Fury, 1989
This bus advertisement and billboard for ACT-UP was banned by Chicago's public-transportation authority.

KNOW YOUR SCUMBAGS

THIS ONE PREVENTS AIDS.

Know Your Scumbags
ACT-UP, New York, 1990
Poster protesting the obstacles
posed by New York's Terence
Cardinal Cooke (and other
church leaders) to the free
distribution of prophylactics

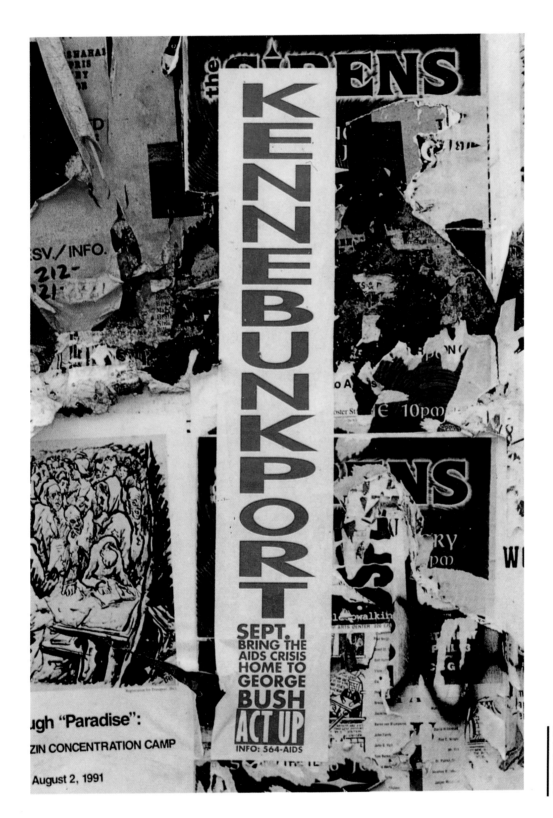

Kennebunkport Sept. 1
Vincent Gagliostro, 1991
Wall poster announcing an
ACT-UP demonstration at
President Bush's summer
retreat

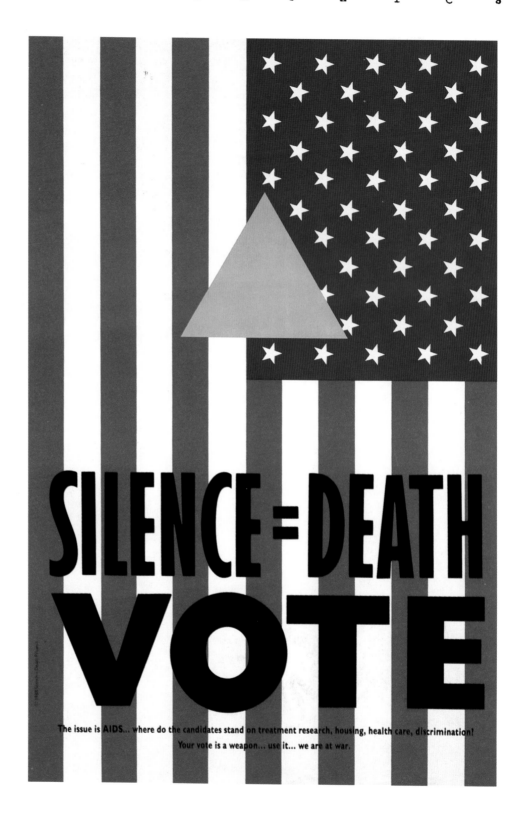

Silence = Death Vote
AIDS Demographics, 1988
Poster for the "Silence =
Death" project urging people
to vote. The pink triangle refers
to the marking given by the
Nazis to homosexual
concentration-camp inmates.

I Hate a Parade
Kathryn Hyatt, 1991
World War 3, New York

*Demand Women's
Health Care*
Sabrina Jones, 1990
WHAM (Women's Health
Action and Mobilization),
New York

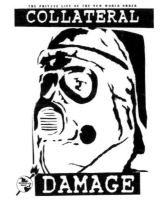

Collateral Damage
Scott Cunningham, 1991
World War 3, New York

68–88
Scott Cunningham, 1990

Information, advice, and inspiration are available from the following organizations:

ACT-UP
135 West 29th Street
New York, NY 10001

The AIDS Coalition to Unleash Power is one of the most vocal advocates for increased spending on AIDS research and health care, social services, and legal protection for those infected with the virus. They specialize in acts of civil disobedience. They also sell tee-shirts, posters and buttons. A catalog is available from the address above.

Central American Solidarity Association (CASA)
1151 Massachusetts Avenue
Cambridge, MA 02138

This organization promotes social justice, peace and political change in Central America through a citizen's exchange program, bringing Central Americans to the U.S. and U.S. citizens to Central America for formal, cultural and political education. CASA also serves as a clearing house for information on Central American issues and publishes a monthly newspaper, the Central America Reporter.

Center for the Study of Political Graphics
8124 West Third Street, Suite 211
Los Angeles, CA 90048

A non-profit educational archive which preserves and disseminates the visual history of grassroots political movements. The center brings exhibitions of posters on controversial issues to schools, libraries, community organizations, galleries and theaters. It has a collection which goes back to the 1940s although most works date from the 1960s to the present. The center welcomes donations of political posters.

Coalition for the Homeless
500 Eighth Avenue, Ninth Floor
New York, NY 10018

An advocacy and service organization which seeks legal and legislative solutions to homelessness. It provides food, counseling, and financial assistance, and attempts to get families and individuals off the streets, out of the shelters, and into permanent housing.

Fireworks Graphics Collective
729 Heinz Avenue #1
Berkeley, CA 94710

For more than a decade this organization has produced posters, stencils, banners, stickers, tee-shirts, and what they call "billboard corrections" on issues including lesbian and gay liberation, Puerto Rican independence, police brutality, and homelessness.

Gay Men's Health Crisis
129 West 20th Street
New York, NY 10011-0022

A community-based organization which, in 1981, began to provide support services to people with AIDS and AIDS-Related Complex (ARC), to educate the public and the health care profession about HIV and AIDS, and to advocate effective public policy and funding for AIDS research and treatment.

Guerrilla Girls
532 LaGuardia Place #237
New York, NY 10012

An anonymous cadre of artists whose posters attack sexism and racism in the art world. They have also done posters protesting the Gulf War and addressing the broader issues of the economic disparity between the sexes. Some of their posters can be purchased mail-order.

PAD/D
c/o the Museum of Modern Art
11 West 53rd Street
New York, NY 10020

An archive of art dealing with social and political issues. Founded in 1980, PAD/D is now housed in the Museum of Modern Art and includes posters and documents organized by category, from abortion rights to Yugoslavia. Founders Barbara Moore and Mimi Smith are no longer running the archive, but it is accessible through MOMA's librarian.

Public Art Fund
1285 Avenue of the Americas, Third Floor
New York, NY 10019

An organization which has, since 1977, brought art to public places in New York City and has bought advertising space to display the work of the Guerrilla Girls, Gran Fury, and Barbara Kruger, among others.

Schomburg Center for Research in Black Culture
515 Lenox Avenue
New York, NY 10031

The art and artifacts section of this library includes political documents and posters protesting apartheid in South Africa and discrimination in the U.S., and works commemorating educational and cultural milestones.

World War 3
Post Office Box 20271
Tompkins Square Station
New York, NY 10009

Published several times a year, this magazine offers political manifestos in comic book form from a variety of professional illustrators and street artists.

Mail order catalogs of political posters are available from a number of sources including:

Liberation Graphics
Box 2394
Alexandria, VA 22301

A free publication called Oppositional Poster Publishing: A Guide for Social Activists is available from Liberation Graphics for a self-addressed stamped envelope.

Northland Poster Collective
1613 East Lake Street
Minneapolis, MN 55407

Northern Sun Merchandising
2916 East Lake Street
Minneapolis, MN 55406

Syracuse Cultural Workers
P.O. Box 6367
Syracuse, NY 13217